328206

KT-174-172

LIBRARY & RESOURCES AREA - EPSOM CAMPUS
THE SURREY INSTITUTE OF ART & DESIGN

Copyright © 1999 by Rockport Publishers, Inc.

All rights reserved. No part of this book may be reproduced in any form without written
permission of the copyright owners. All images in this book have been reproduced with
the knowledge and prior consent of the artists concerned and no responsibility is accept-
ed by producer, publisher, or printer for any infringement of copyright or otherwise,
arising from the contents of this publication. Every effort has been made to ensure that
credits accurately comply with information supplied.

First published in the United States of America by
Rockport Publishers, Inc.
33 Commercial Street
Gloucester, Massachusetts 01930-5089
Telephone: (978) 282-9590
Facsimile: (978) 283-2742

Distributed to the book trade and art trade in the United States by
North Light Books, an imprint of
F & W Publications
1507 Dana Avenue
Cincinnati, Ohio 45207
Telephone: (800) 289-0963

Other distribution by
Rockport Publishers, Inc.
Gloucester, Massachusetts 01930-5089

ISBN 1-56496-602-x

10 9 8 7 6 5 4 3 2 1

741.GMIL

328206

DESIGN> chad reynolds/stoltze design
COVER IMAGE> chad reynolds

Printed in China

*graphic
design
speak

**A VISUAL DICTIONARY
FOR DESIGNERS AND CLIENTS**

anistatia r miller
jared m. brown

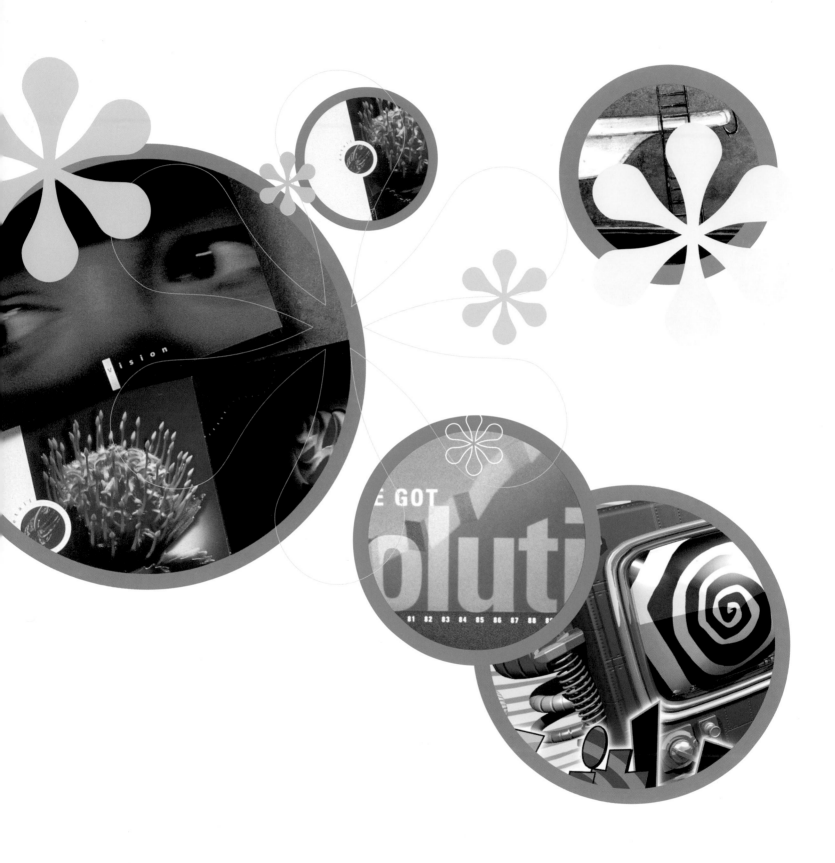

contents

introduction

> Mark Twain once said, "The difference between the right word and a word is the difference between lightning and a lightning bug." The words used to explain what a client wants and what a designer feels must hit with the impact of a late-summer electrical storm. However, the way in which clients verbalize their vision radically differs from the way designers "visualize" those same concepts. "Clients find it hard to articulate what they want creatively," one creative director commented. "They don't work in our industry, often don't understand the jargon. So we can't expect them to be able to communicate their desires with ease."

A common solution to this language problem is for designers to bring visual aids to the design briefing: reference books, samples of design styles, and examples of work that express the same emotion or sensation that the message requires. It would take weeks to accumulate and a luggage carrier to transport such a library of reference material to a meeting. That's why we created *Graphic Design Speak: A Visual Dictionary for Designers and Clients*, the first easy-to-use and invaluable reference tool that presents visual definitions of adjectives commonly used to describe design concepts. What do words like *innovative*, *bold*, and *sexy* really look like? This collection of the finest new works from designers around the world provides some quick answers.

Over one hundred designers from studios in more than a dozen countries contributed nearly three hundred of their best works for this project, as well as their comments and views on a wide range of design topics. The results were surprising; it seems as if visual language has become nearly universal, despite cultural and geographical differences. But this is a new generation of designer and a new generation of design. Decades of common influences, such as Bauhaus, de Stijl, expressionism, and postmodernism, have helped to shape these shared understandings.

Arranged in alphabetical order, **Graphic Design Speak** allows designers, clients, and anyone interested in graphic design to seek specific information and inspiration about twenty-six adjectives. As you wander through these pages, you might begin to understand the adage "One picture is worth more than ten thousand words."

"One picture is worth more than ten thousand words."

basique = **wesentlich** = **basic** = **básico** = **essenziale** = 基本 = 基本的 = **basic**

Paring a message to its essential elements is what a basic design solution must do. This means portraying only the fundamental visual and verbal ingredients of the message. A basic design can also imply that all the elements used in the presentation are resistant to replacement; no visual metaphors or symbols universally convey the same meaning.

"We always dive into the briefing by comparing the product with existing items, examing the manufacturing processes, and investigating competitors before describing what the client really wants."

Kees Uittenhout,
Designstudio Kees Uittenhout BMO

LIBRARY & RESOURCES AREA - EPSOM CAMPUS

THE SURREY INSTITUTE OF ART & DESIGN

PROJECT> RWU GmbH & Co.
KG Corporate Design
DESIGN FIRM> Dirk Rullkötter AGD
(Advertising + Design),
Kirchlengern, Germany
CLIENT> RWU GmbH & Co. KG,
Löhne, Germany
ART DIRECTOR/DESIGNER> Dirk Rullkötter

The corporate identity not only serves as a visual brand but also communicates about the company. It can do much more than this, but this communication is its essence. The logo created for RWU GmbH, a recycling enterprise, carries a subtle message about the cyclical and environmentally sound nature of recycling, with its rotational arrow and green color.

RWU
GmbH & Co. KG

Recycling
Wiederverwendbare
Unterlagen

VAN HERPT ARCHITECTEN

PROJECT> Van Herpt
Architects Housestyle
DESIGN FIRM> Designstudio Kees
Uittenhout BMO,
Wijk en Aalburg, Netherlands
CLIENT> Van Herpt Architects,
Nuenen, Netherlands
ART DIRECTOR> Kees Uittenhout
DESIGNER> Mik Wolkers

As architects' logos appear on the page with their designs, it is important that they don't draw attention away from the work itself. However, as Kees Uittenhout's work attests, *basic* refers to design in the absence of unnecessary embellishment.

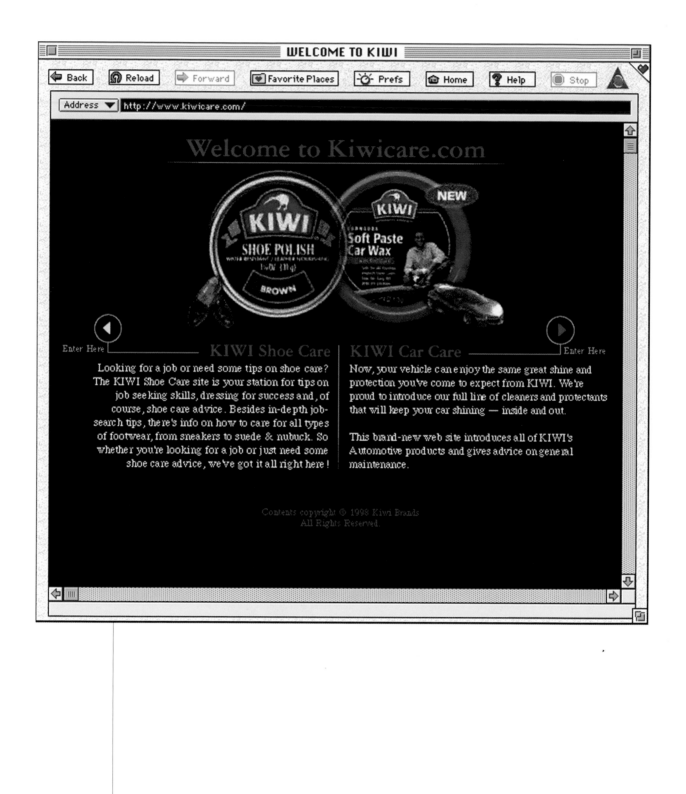

PROJECT> Kiwi Brands Web Site
(www.kiwicare.com)
DESIGN FIRM> Orbit Integrated,
Hockessin, Delaware, USA
CLIENT> Kiwi Brands, Douglassville,
Pennsylvania, USA
ART DIRECTOR> Andy Mathers
DESIGNER> Andy Mathers

The client asked this Web-design firm to create a site that had growth potential and a clean, basic visual approach. An uncluttered minimum of visual elements and a plain background highlight the products, which are inevitably the essential visual components in any commercial design.

PROJECT> Mask 1, Mask 2, Mask 3
12-Inch Single Labels
DESIGN FIRM> Studio Moo,
Manchester, England
CLIENT> Skam Records,
Manchester, England
ART DIRECTOR/DESIGNER> Brian Flanagan

Less truly is more. The minimalist treatment of this series of record labels establishes a strong visual cohesiveness among them. It also ensures that they stand out in comparison to more cluttered labels and make enough of an impression that the records are not remembered for the music alone. Like road signs, these labels are instantly recognizable and readable.

300
appearing in no particular order:

vendor refill
foreign terrain
thought universe
covork
mear
plateau
metamatics

effronté = keck = zwaar = negrito = audaz = coraggioso = 大膽 = 大胆 = bold

A bold design implies that both the designer and the client are willing to step beyond the limits of conventional thought or action, creating a radical departure from the competition's visual persona. The images, color palette, font, and overall texture in such a solution are striking or flashy. Each element is purposefully and fearlessly selected and positioned to catch the viewer's attention. Fonts are heavy, colors are bright, and shapes evince high impact. (Remember the Pow! Wham! Zap! graphics from the 1970s *Batman* television series?) The result is best described as in your face.

"Ultimately, good design is sourced at a place common to all of us. It comes down to visually conveying an idea that anyone can recognize, and yet has the interest of being revealed in a new way. A basic human truth is that our desire for comfort is equally matched by a need for intrigue. When both are delivered equally, you have created a pattern....Perhaps small, but nonetheless, an evolutionary step."

Maggie Macnab,
Macnab Design Visual Communication

PROJECT> **Major League Soccer Players Association Identity**
DESIGN FIRM> **Grafik Communications, Alexandria, Virginia, USA**
CLIENT> **Major League Soccer Players Association, Washington, DC, USA**
DESIGNERS> **Jonathan Amen, David Collins, Judy Kirpich**

The Grafik Communications design team needed to create a bold, high-impact identity on a minimum budget for a sports association. By combining a four-color sticker, which was ganged with the mailing label, and a colored, plain-pocket folder, they were able to create an interesting four-color presentation. The muted tones of bright colors yield a bold but still highly legible solution.

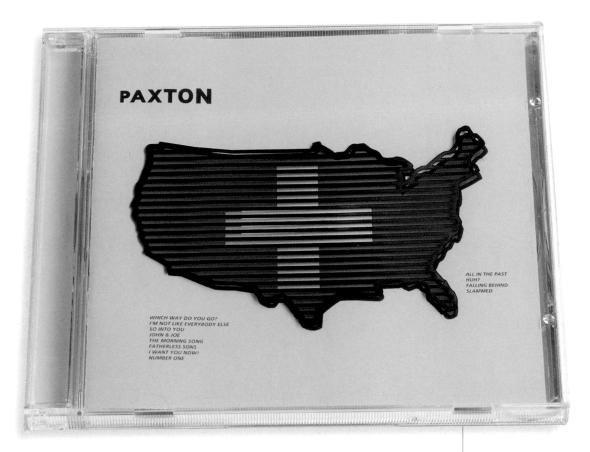

PAXTON

WHICH WAY DO YOU GO?
I'M NOT LIKE EVERYBODY ELSE
SO INTO YOU
JOHN & JOE
THE MORNING SONG
FATHERLESS SONS
I WANT YOU NOW!
NUMBER ONE

ALL IN THE PAST
HUH?
FALLING BEHIND
SLAMMED

PROJECT> *Paxton* CD Cover
DESIGN FIRM> Sagmeister, Inc.,
New York, New York, USA
CLIENT> Nemperor Records,
New York, New York, USA
ART DIRECTOR> Stefan Sagmeister
DESIGNERS> Hjalti Karlsson,
Stefan Sagmeister
PHOTOGRAPHERS> Neal Preston,
Darryl Snaychuk, Tom Schierlitz

Printed directly onto the plastic jewel case, the bold United States map graphic on this CD for Tom Paxton changes from positive to negative, reflecting the ambivalence of the songwriter's lyrics. The flag on the back cover transforms into a functional bar code as well. The interplay among the contrasting colors adds to the effect.

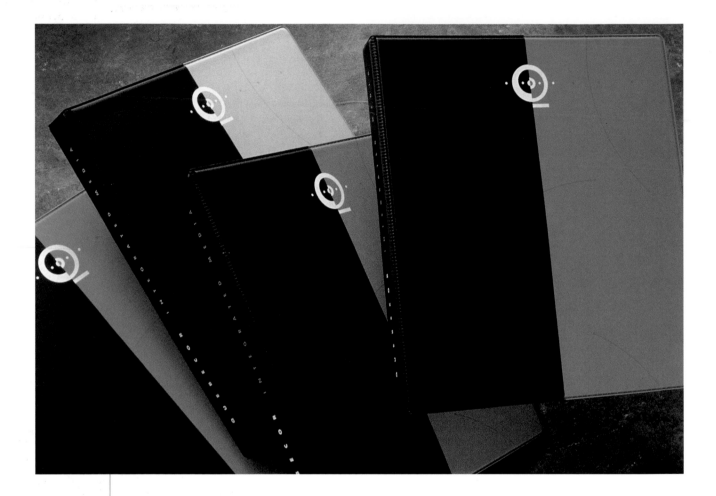

PROJECT> **Quebecor Integrated**
Media Binders
DESIGN FIRM> **Hornall Anderson**
Design Works, Inc.,
Seattle, Washington, USA
CLIENT> **Quebecor Integrated Media,**
Tacoma, Washington, USA
ART DIRECTOR> **Jack Anderson**
DESIGNERS> **Jack Anderson, Heidi Favour,**
Mary Hermes, Mary Chin Hutchison

To create a bold set of presentation binders that would fit within Quebecor's visual style (which was also created by Hornall Anderson), Jack Anderson used the company's bright, established colors against a black back-drop with a reversed Quebecor logo as the only image on the cover, creating a striking and uncluttered solution. Simplicity lends strength to this design.

PROJECT> **A Living Memorial to the Holocaust Presentation Folder**
DESIGN FIRM> **Grafik Communications, Alexandria, Virginia, USA**
CLIENT> **Museum of Jewish Heritage, New York, New York, USA**
DESIGNERS> **Judy Kirpich, Gretchen East, Claire Wolfman, Michelle Mar, David Collins, Kristin Moore**

The client wanted to present museum goers with an upbeat yet respectful look for this major cultural institution. Using this approach, the design team developed materials that were both dignified and lively. A narrow range of colors and conservative type treatments emphasize the already strong images.

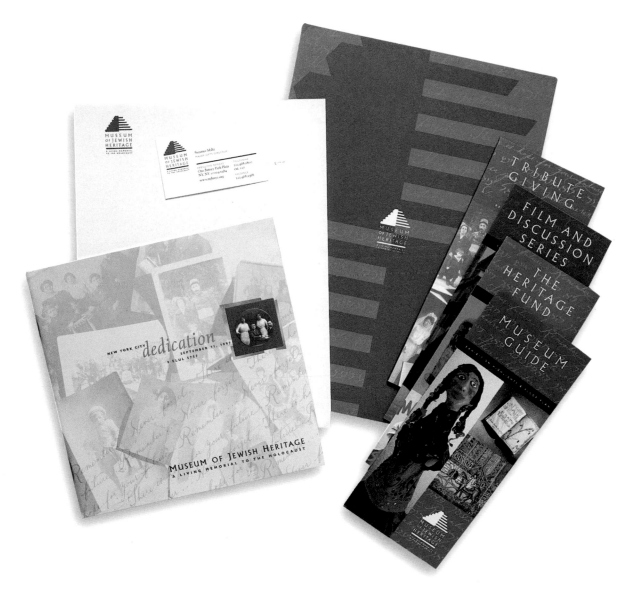

PROJECT> FontShop Germany Web Site
(www.fontshop.de)
DESIGN FIRM> U.R.L. Agentur für
Informationsdesign GmbH, Vienna, Austria
CLIENT> FontShop Germany, Berlin, Germany
ART DIRECTOR/ILLUSTRATOR> Tina Frank
WEB DESIGNER/DESIGNER> Tina Frank
ANIMATOR/PROGRAMMER> Andreas Pieper

Studies show that the most readable combinations of text and background are yellow on black and black on yellow—not coincidentally, also the boldest. Words scream off the page, but they are legible (unlike red on green and orange on yellow). The next clearest combinations are the most common: black on white and the reverse. The FontShop logo uses both of these in a bold example of the company's product.

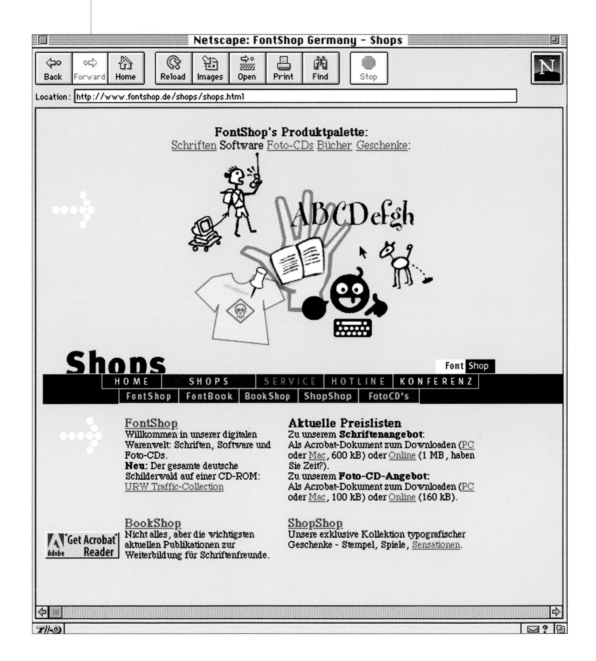

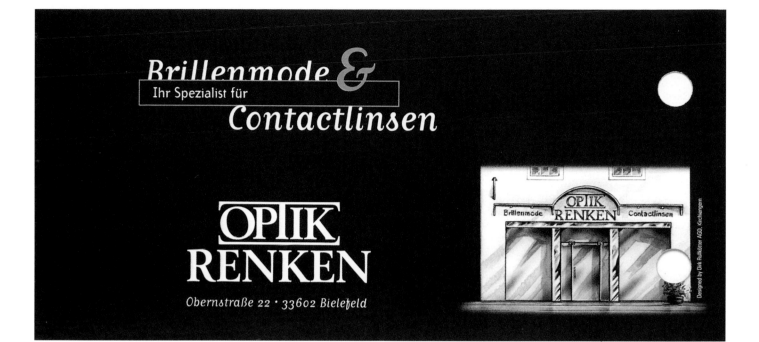

Designed by Dirk Rullkötter AGD, Kirchlengern.

PROJECT> Optik Renken Invitation Card
DESIGN FIRM> Dirk Rullkötter AGD
(Advertising + Design),
Kirchlengern, Germany
CLIENT> Optik Renken, Bielefeld, Germany
DESIGNER> Dirk Rullkötter

The client, an optical shop, wanted an invitation that would be difficult to ignore. The design team at Dirk Rullkötter AGD produced this striking graphic on cardstock. The weight of the paper and the two holes on the end made it possible to slip the card onto a long-stemmed red rose for a truly bold presentation. The colors complement and accent the flower's red and green tones.

lumineux = glaenzend = helder = claro = vivace = 出色 = 明るさ = bright

A bright idea. A bright person. A bright and sunny day. The images these phrases elicit are tied by strong common threads: all are dynamic, all are positive, and all have inherently upbeat energy. In graphic design, this translates to a high ratio of light to shadow and of color and texture to barren space. The palette draws from sunny summer days, where colors stand out brilliantly. Shapes are often filled with easy motion and come to the fore in clear definition.

"Designers must develop verbal communication skills to avoid misunderstandings of the client's desires and the designer's solutions."

Adrian Shaughnessy,
Intro Design

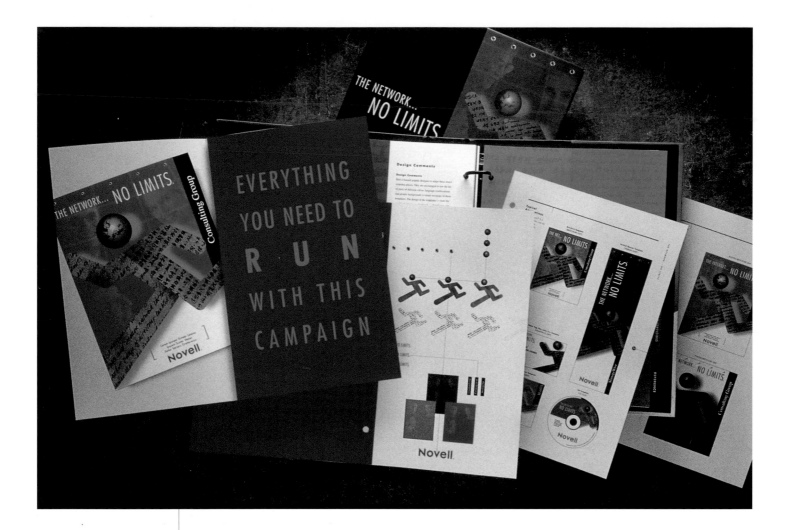

PROJECT> Novell *No Limits* Guidelines Manual
DESIGN FIRM> Hornall Anderson
Design Works, Inc.,
Seattle, Washington, USA
CLIENT> Novell, Inc., Orem, Utah, USA
ART DIRECTOR> Jack Anderson
DESIGNERS> Jack Anderson, Larry Anderson,
Margaret Long, Sonja Max, Taro Sakita, Virginia
Le, Michael Brugman
PHOTOGRAPHER> Paula Schnesse

Though motion is not essential for creating bright design solutions, it clearly adds to the overall effect. The running person, as a repetitive motif appearing in a multitude of colors, gives a dynamic emphasis to this guidelines manual created by Hornall Anderson Design Works.

PROJECT> *Exposure Film and Arts*
Magazine Format Design
DESIGN FIRM> Inkahoots Design,
Brisbane, Queensland, Australia
CLIENT> Brisbane Independent Filmmakers,
Brisbane, Queensland, Australia
ART DIRECTOR/DESIGNER> Jason Grant
ILLUSTRATOR> Shing Mo

Film and arts magazines tend to have understated, intellectual, and high-art covers and cover designs. Standing next to them on the shelf, *Exposure Film and Arts* magazine screams out like raspberry sorbet on a beige carpet. As the pace of both industries continues to quicken, the brighter, louder, and faster design will sell more magazines.

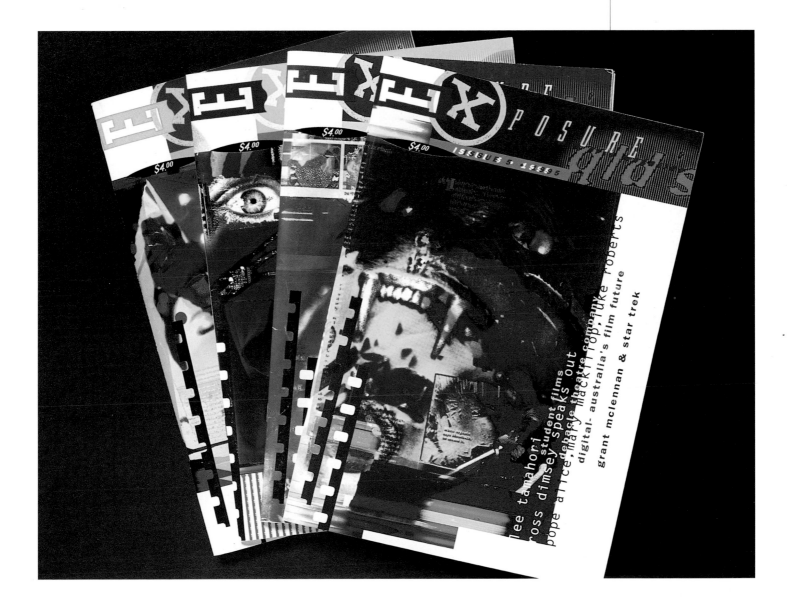

PROJECT> **Bikes, Bands,**
Strategic Plans Planning Kit
DESIGN FIRM> **Inkahoots Design,**
Brisbane, Queensland, Australia
CLIENT> **Local Government Association,**
Brisbane, Queensland, Australia
ART DIRECTOR/DESIGNER> **Jason Grant**

Studies on color conducted in the
1960s and 1970s showing that bright
colors stimulate mental activity—that
is, wake people up—led many major
corporations to repaint their work areas.
The brilliant tones on these strategic
plans enlivens them and their readers.

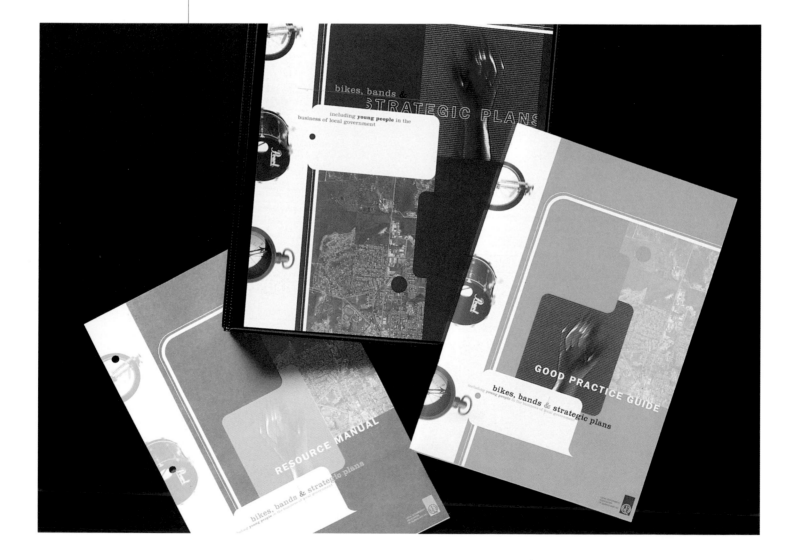

PROJECT> *Firefly Nexus* CD Cover
DESIGN FIRM> Inkahoots Design,
Brisbane, Queensland, Australia
CLIENT> Firefly,
Brisbane, Queensland, Australia
ART DIRECTOR/DESIGNER> Jason Grant

This frenetic, chaotic combination of photos and illustrations created by Inkahoots Design is hot, both in imagery and coloration. The design plays off the band's name, subtly reinforcing the branding while emphasizing the fun factor of the music.

The world is becoming increasingly impersonal. Face-to-face conversation is being rapidly replaced by phone, fax, FedEx, and modem communication. Impersonal formality in design, used to add the strength of visual credibility to everything from corporate identities to personal resumes, has lost some of its power as a result. Casual design solutions are the equivalent of a handwritten note in a sea of business cards. Elements of humor, handwritten fonts, and casual photographs should reveal a client's or corporation's personality. Casual elements for design solutions can be found in everyday life. From denim and sneakers to weekend sports and other leisure-time activities, the sources of imagery and inspiration are endless.

"Many clients find it difficult to visualize their ideas. Often they will find it very helpful if a design firm works with them to help them see what they really want. For the designer, it's a matter of listening very carefully, asking lots of questions, and often of 'reading between the lines' to interpret messages."

Anya Colussi,
Yfactor, Inc.

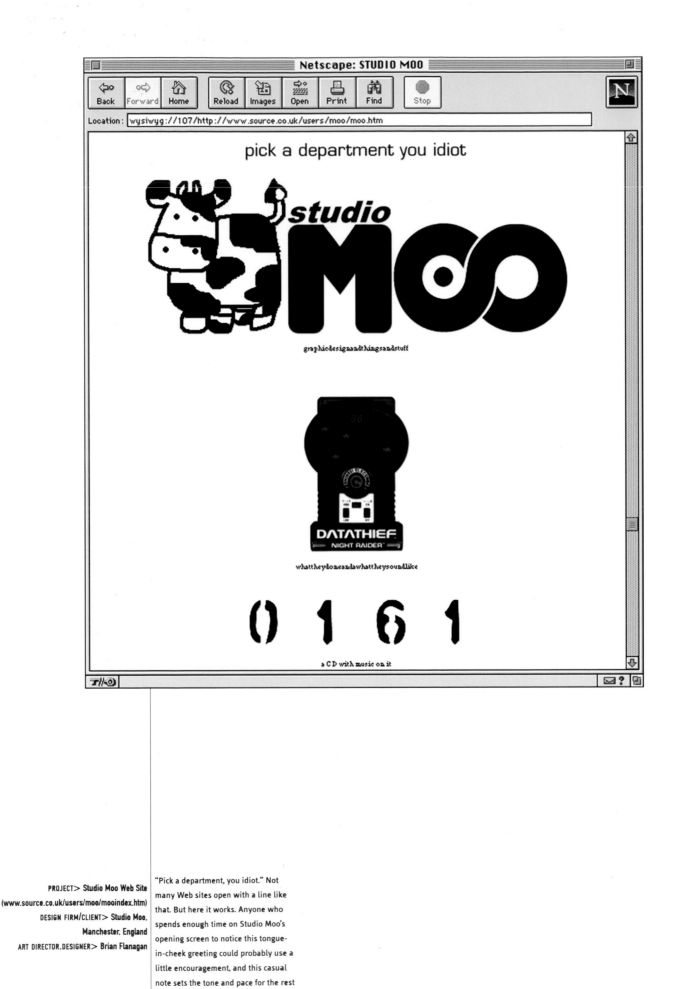

PROJECT> **Studio Moo Web Site**
(www.source.co.uk/users/moo/mooindex.htm)
DESIGN FIRM/CLIENT> **Studio Moo,**
Manchester, England
ART DIRECTOR.DESIGNER> **Brian Flanagan**

"Pick a department, you idiot." Not many Web sites open with a line like that. But here it works. Anyone who spends enough time on Studio Moo's opening screen to notice this tongue-in-cheek greeting could probably use a little encouragement, and this casual note sets the tone and pace for the rest of this highly animated site.

PROJECT> **Danone Olé Potato Chips**
Package Design
DESIGN FIRM> **The Bonsey Design**
Partnership, Singapore
CLIENT> **Danone, Singapore**
ART DIRECTOR> **Jonathan Bonsey**
DESIGNER> **Mia Watten**

In an outstanding example of the versatility of type, the Bonsey Design Partnership gave Olé Potato Chips a face and a personality. As Bonsey explains, "Olé's new identity creates a colorful expression of the brand through the characterization of the brand name itself. The quizzical eyebrow raised with a Gallic charm invites the customer to be part of the brand."

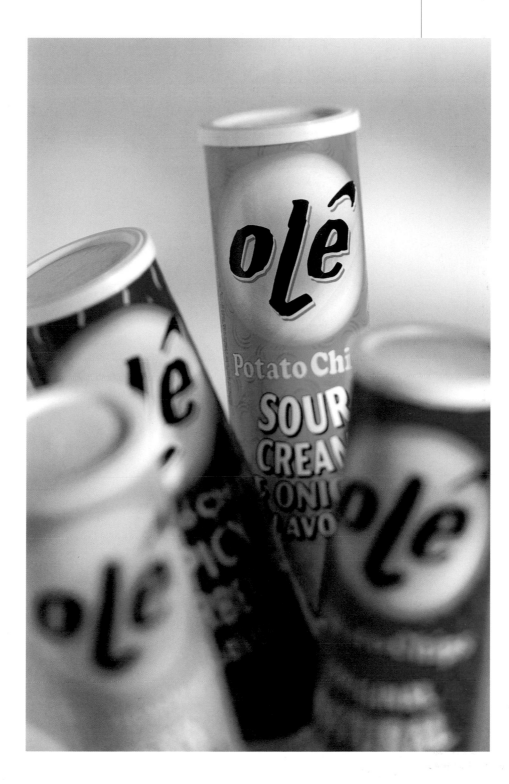

PROJECT> AirTouch Cellular
TalkAlong Packaging
DESIGN FIRM> Hornall Anderson
Design Works, Inc.,
Seattle, Washington, USA
CLIENT> AirTouch Cellular,
Bellevue, Washington, USA
ART DIRECTOR> Jack Anderson
DESIGNERS> Jack Anderson, Mary Hermes,
Margaret Long, Debra McCloskey,
Mary Chin Hutchison
ILLUSTRATOR> Burton Morris

Casual, cartoonish illustration can breathe life into inanimate objects and imbue them with personality, as seen on this AirTouch Cellular TalkAlong packaging created by designers at Hornall Anderson. The phone comes vibrantly to life. Paired with images of happy, busy people, the image of the phone strongly implies that it is both fun and useful.

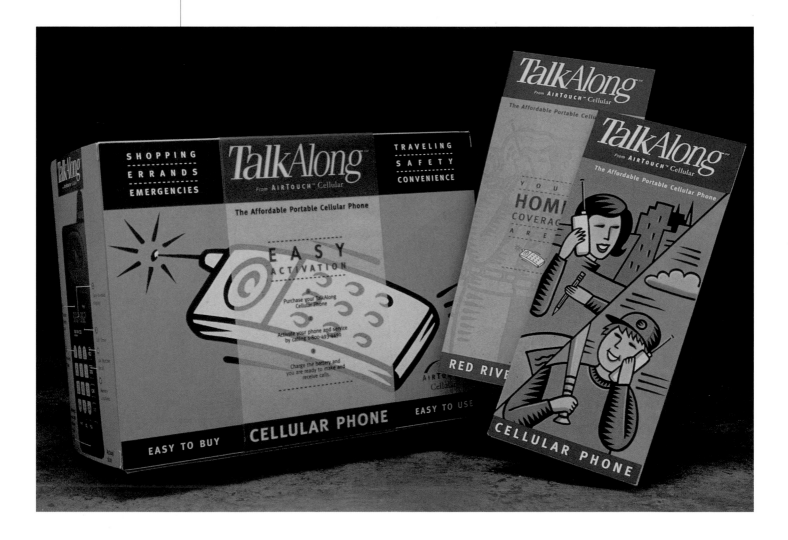

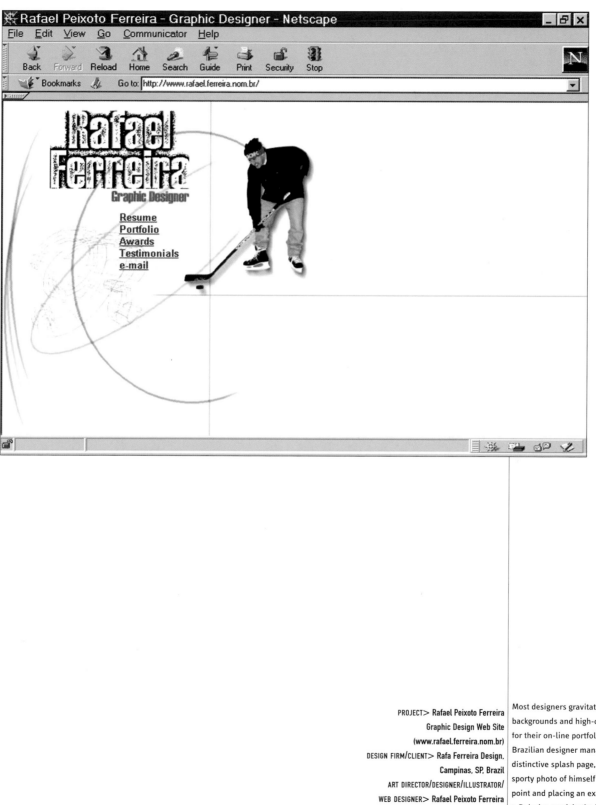

PROJECT> **Rafael Peixoto Ferreira**
Graphic Design Web Site
(www.rafael.ferreira.nom.br)
DESIGN FIRM/CLIENT> **Rafa Ferreira Design,**
Campinas, SP, Brazil
ART DIRECTOR/DESIGNER/ILLUSTRATOR/
WEB DESIGNER> **Rafael Peixoto Ferreira**

Most designers gravitate toward black backgrounds and high-concept graphics for their on-line portfolios. This Brazilian designer managed to create a distinctive splash page, applying a sporty photo of himself as the focal point and placing an example of his 3-D design work in the background. Without losing the opportunity to showcase his talent, he also invites potential clients to identify with him and get to know him through his site.

net = sauber = schoon = limpo = limpio = innocente = 簡潔 = 清浄 = clean

Clean means that an image or an entire solution
is characterized by a fresh, wholesome quality.
Purity and simplicity are essential traits of
the overall concept. Visuals that are not ornate
or overembellished can be described as clean.
Gracefully spare, streamlined, forceful yet
simple, a clean design solution means more
than lacking in pictures or text.

*"Design is a matter of order against
chaos. Organizing the information for a
big project is one of the most important
steps in the design process. You cannot
communicate in a clear way something
that is not clear."*

**Tomas Garcia Ferrari and Carolina Short,
Bigital**

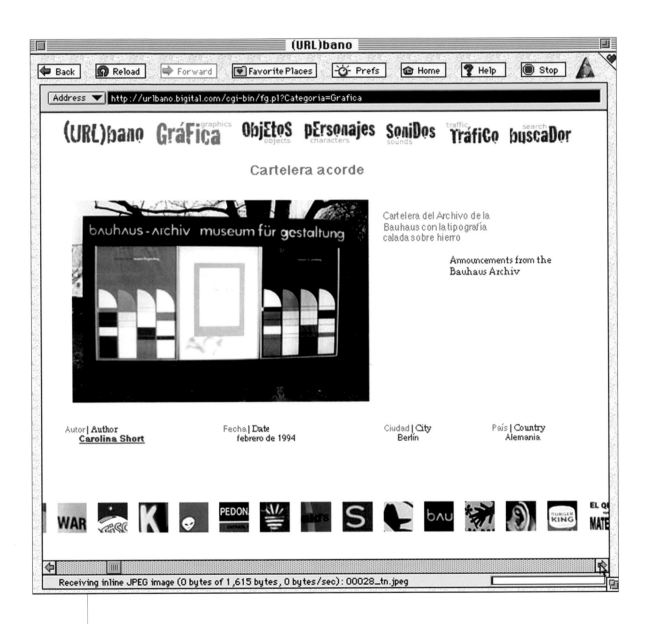

PROJECT> (URL)bano Web Site
(www.urlbano.bigital.com)
DESIGN FIRM> Bigital,
Buenos Aires, Argentina
CLIENT> (URL)bano,
Buenos Aires, Argentina
ART DIRECTORS/DESIGNERS> Tomas Garcia
Ferrari, Carolina Short

Every detail of this Web site is clean and controlled. Carolina Short explains, "The user must interact with its interface in a transparent way. We can play with the boundaries of understanding, but be very careful of not falling down. We cannot allow the reader to feel confused or bored." Visitors see a slightly different view each time they stop by because the opening screen sequences the clickable images randomly.

PROJECT> *Anacomp Corporate Style Guide*
DESIGN FIRM> **Mires Design, Inc.,**
San Diego, California, USA
CLIENT> **Anacomp, Encinitas, California, USA**
ART DIRECTOR> **John Ball**
DESIGNERS> **John Ball, Deborah Hom**
ILLUSTRATOR> **Miguel Perez**

The *Anacomp Corporate Style Guide* was designed as a tool to help both internal and external audiences implement the company's new identity. To encourage compliance with the new graphic standards, the design team kept the guidelines simple and direct. The presentation itself was kept accessible, engaging, and clean. Swatches were provided of Anacomp's corporate color, with secondary color palettes provided in PMS, CMYK, and RGB formats.

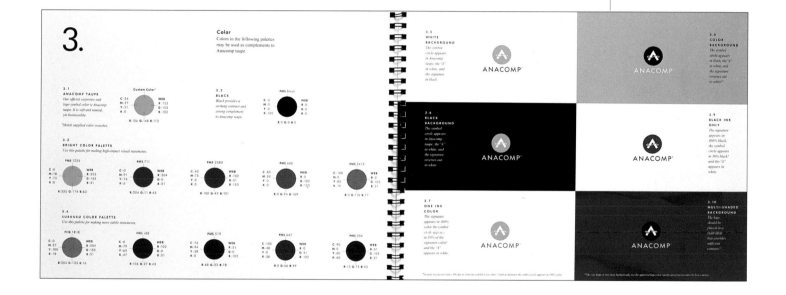

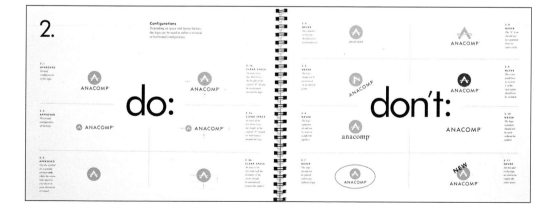

PROJECT> **Anni Kuan Stationery**
DESIGN FIRM> **Sagmeister, Inc.,**
New York, New York, USA
CLIENT> **Anni Kuan, New York, New York, USA**
ART DIRECTOR> **Stefan Sagmeister**
DESIGNERS> **Hjalti Karlsson,**
Stefan Sagmeister

This business card for a New York fashion designer consists of two very clean, abstract patterns. The logo appears and becomes readable only when the card is folded. The same treatment is applied to the stationery. The logo is complete when the letterhead is inserted into the transparent envelope.

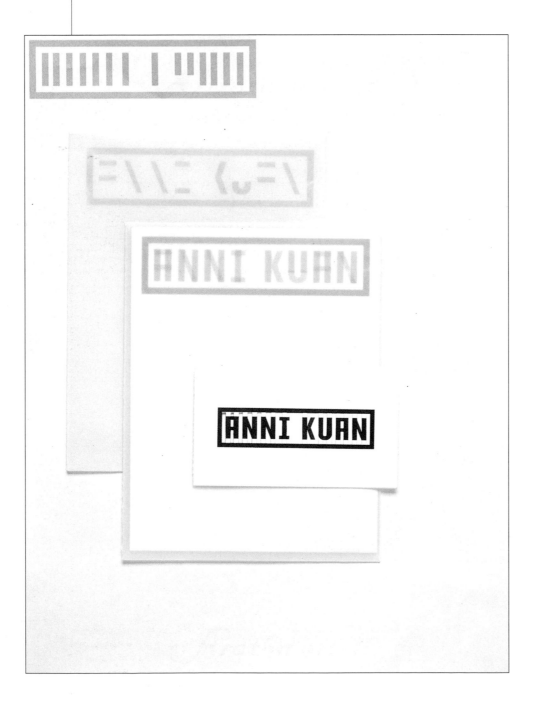

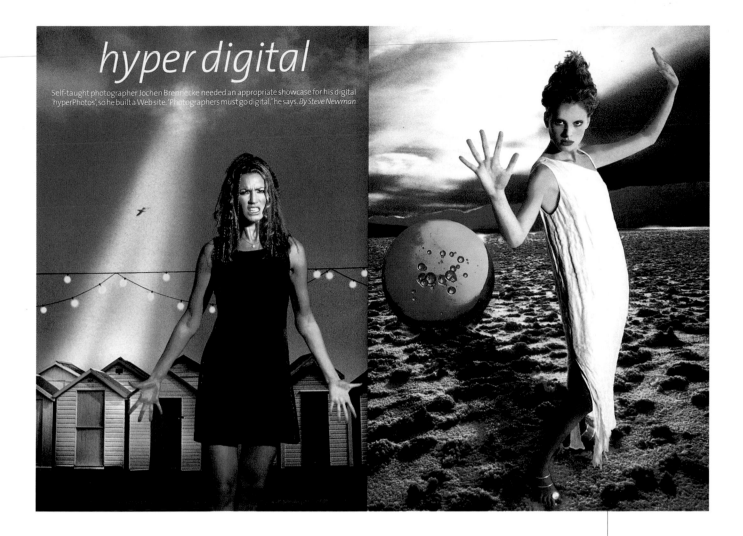

hyper digital

Self-taught photographer Jochen Brennecke needed an appropriate showcase for his digital 'hyperPhotos', so he built a Web site. 'Photographers must go digital,' he says. *By Steve Newman*

Rhythm of Life

As well as uniting body and soul, Scru Tiny in the Great Round marries the technical and aesthetic. Sue Weekes meets the makers of this landmark CD-ROM

PROJECT> *Creative Technology* Magazine
DESIGN FIRM/CLIENT> **Haymarket Trade and Leisure Publications, Teddington, England**
ART DIRECTOR/DESIGNER> **Wayne Ford**
PHOTOGRAPHERS> **Colin Stout, Chris George, Jochen Brennecke**
ILLUSTRATOR> **Bugsy G. Riphead**

The overall approach to this publication was to keep the typography simple and modern. Combining white space and strong use of illustration and photography, Ford developed a clean yet flexible format for this professional publication.

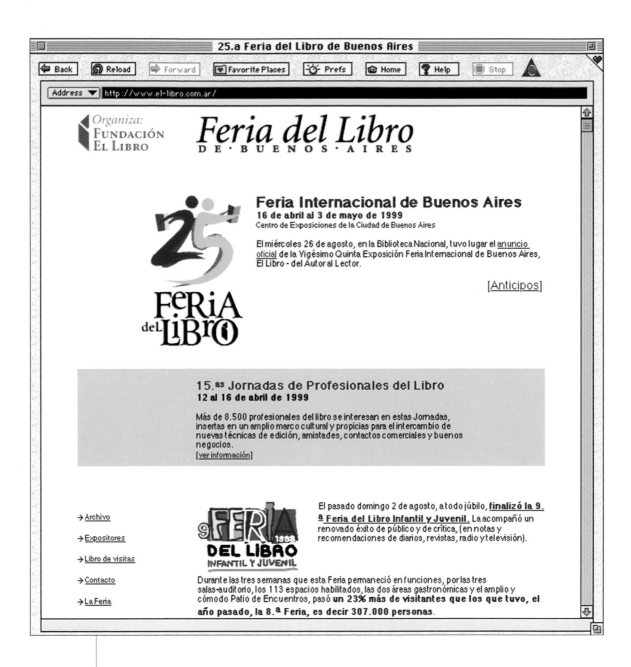

PROJECT> **Buenos Aires Book Fair**
(www.el-libro.com.ar)
DESIGN FIRM> **Bigital,**
Buenos Aires, Argentina
CLIENT> **Fundación El Libro,**
Buenos Aires, Argentina
ART DIRECTORS/DESIGNERS> **Tomas Garcia**
Ferrari, Carolina Short
PROGRAMMER> **Daniel Laco**

Bigital's Carolina Short believes clean design solutions reflects her design philosophy. As she says, "Design is a matter of order against chaos. Organizing the information for a big project is one of the most important steps in the design process. You cannot communicate in a clear way something that is not clear."

PROJECT> **Taylor Guitars Apparel Logos**
DESIGN FIRM> **Mires Design, Inc.,**
San Diego, California, USA
CLIENT> **Taylor Guitars,**
El Cajon, California, USA
ART DIRECTOR> **Scott Mires**
DESIGNER> **Miguel Perez**
ILLUSTRATOR> **Michael Schwab**
CALLIGRAPHY> **Judythe Sieck**

Taylor Guitars wanted a clean-looking design solution for this promotional identity system for their line of branded apparel. The use of a single visual element and a single text element illustrate the fact that designing clean images does not limit creativity.

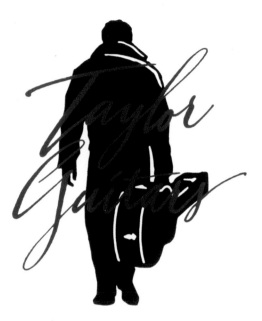

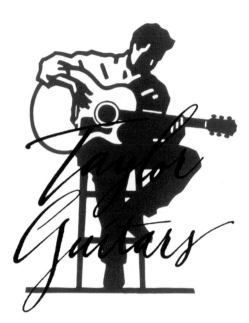

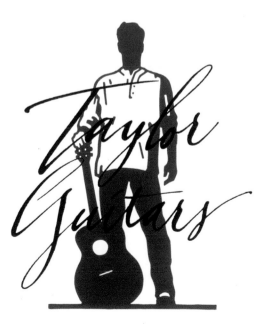

CO

From royal to navy to midnight, blue is the first color of corporate design. Blame it on Paul Rand, creator of IBM's corporate identity (Big Blue). Its success lies in its ability to portray success, though it is by no means the only color capable of this. A corporate solution may appear to be impersonal, but to the business-minded audience toward which it is appropriately directed, images of corporate vitality, advanced technology, and industrial strength are as compelling as Porsche convertibles are to middle-aged men. The client's latest, most innovative, or most prominent products or services provide the strongest images for this form of visual communication. Other elements, such as fonts and colors, are generally employed conservatively.

"Designers are not always clever enough to listen and conclude for themselves what they wish to communicate to the client."

Kees Uittenhout,
Designstudio Kees Uittenhout BMO

RPORATE

PROJECT> Leith Wheeler
Investment Counsel Ltd. Web Site
(www.leithwheeler.com)
DESIGN FIRM> Bo2 Productions,
North Vancouver, British Columbia, Canada
CLIENT> Leith Wheeler Investment Counsel Ltd.,
Vancouver, British Columbia, Canada
ART DIRECTOR/DESIGNER> Boris Chow

Serious investors spend more time surrounded by the tools of the investors' art than they do amid the trappings of luxury. This navigational screen for Leith Wheeler Investment Counsel Ltd. is designed to become the investor's virtual desk. The same approach can be applied to any target market, but first the designer must understand the end user.

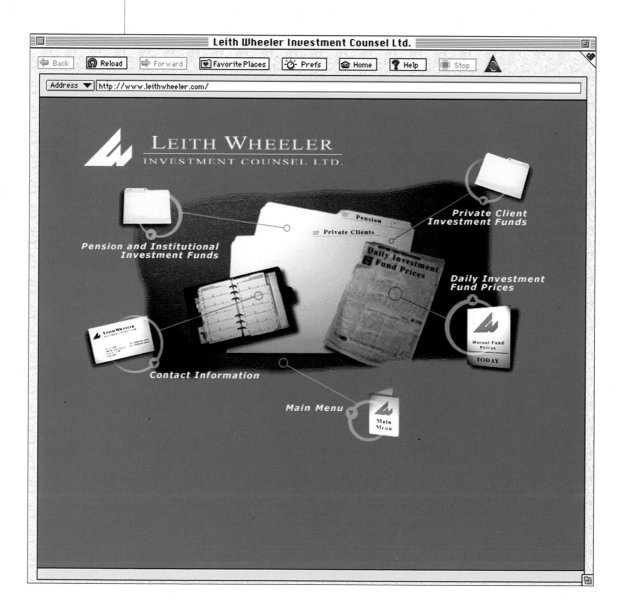

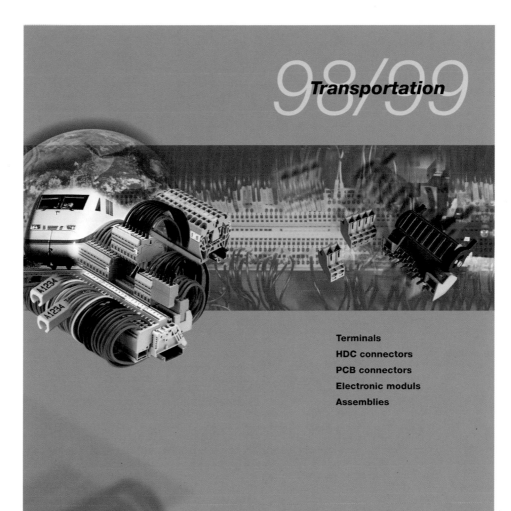

98/99
Transportation

Terminals
HDC connectors
PCB connectors
Electronic moduls
Assemblies

Weidmüller

Die Interface Partner

PROJECT> **Weidmüller Group**
Transportation 98/99 **Catalog**
DESIGN FIRM> **Dirk Rullkötter AGD**
(Advertising + Design),
Kirchlengern, Germany
CLIENT> **Weidmüller Group, Detmold, Germany**
ART DIRECTOR/DESIGNER> **Dirk Rullkötter**

The variety of images on the cover of this catalog created for Weidmüller Transportation, a producer of terminals and connectors, by Dirk Rullkötter AGD reveals both the products and the scope of their application (from high-speed trains to the world at large). The cover also shows that sculptural qualities can be uncovered in unusual objects, like transistors. These qualities can, in turn, be exploited for increased visual impact.

PROJECT> K-Line Construction
Promotional Material
DESIGN FIRM> Terrapin Graphics,
Toronto, Ontario, Canada
CLIENT> K-Line Construction Limited,
Woodstock, New Brunswick, Canada
ART DIRECTOR/DESIGNER> James Peters
ILLUSTRATOR> James Peters

This mix of traditional images and
innovative layouts results in a fresh,
professional look for a corporate
presentation folder. The flexible format
James Peters developed for the page
design allowed him to create distinctly
different layouts within a highly
cohesive whole.

PROJECT> **The Modern Group**
Corporate Profile
DESIGN FIRM> **The Bonsey Design**
Partnership, Singapore
CLIENT> **PT Intramodern, Indonesia**
ART DIRECTOR> **Jonathan Bonsey**
DESIGNER> **Mark Chung**
PHOTOGRAPHER> **Art Li**
ILLUSTRATOR> **Stuart Briers**

Red is corporate design's other grand color. Here, it lends a cohesive warmth to a corporate profile of the four divisions of The Modern Group, one of Indonesia's most successful conglomerates.

CRIS

160su ti

audacieux = frisch = bros = crocante = directo = acuto = 鮮明 = シャッキシャッキ

P

crisp

Although a crisp image is also clean and fresh, it takes a big step forward. Filled with vigor and substance, a crisp design is also lively and scintillating. It maintains a wholesome, spare quality while introducing a pithy but not necessarily bold attitude. Think of the more subtle and ethereal elements of a crisp autumn day: clearly defined colors and unmuddled lines, elements that play off each other, providing high contrast without clashing.

"I interview and discuss with a client what he or she wants to create; I draw a rough sketch or chart at the same time in front of them. By showing visual samples, the concept is recognized and the meaning of words can be shared."

Kimihiko Yoshimura,
Mihama Creative Associates

PROJECT> FontShop Austria Web Site
(www.fontshop.co.at/fontshop)
DESIGN FIRM> U.R.L. Agentur für
Informationsdesign GmbH,
Vienna, Austria
CLIENT> FontShop Austria, Vienna, Austria
ART DIRECTOR/DESIGNER> Tina Frank
ILLUSTRATOR> Tina Frank
PROGRAMMER> Andreas Pieper

Brightly colored images silhouetted on a white background stand out in any presentation. In this FontShop Austria Web site, the combination of bright colors and ample white space allows the site to deliver quite a bit of information up front without appearing cluttered or crowded.

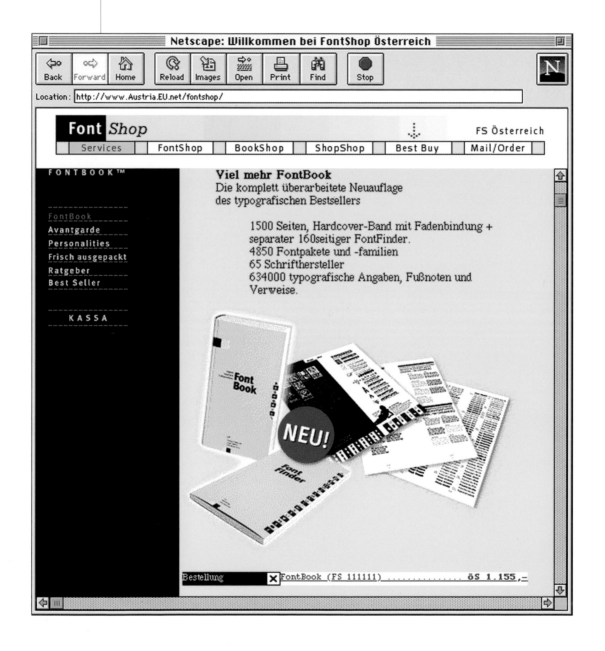

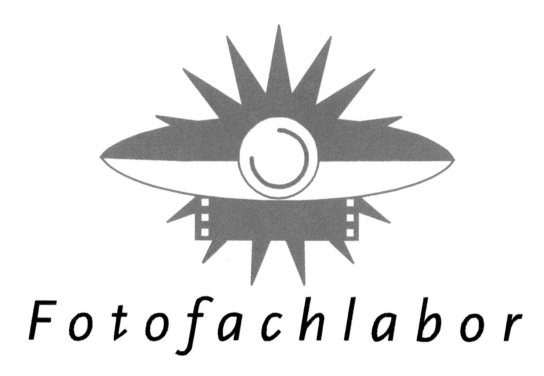

Fotofachlabor

PROJECT> Fotofachlabor Logo
DESIGN FIRM> Dirk Rullkötter AGD
(Advertising + Design),
Kirchlengern, Germany
CLIENT> conceptional artwork,
Kirchlengern, Germany
ART DIRECTOR/DESIGNER> Dirk Rullkötter

Strong geometric lines and bold colors boost the readability of a logo, which will be employed in a range of sizes and situations. But this approach can be applied to nearly any illustrative material. This logo combines familiar elements—film, flash, and lens—to imply photography without showing a camera.

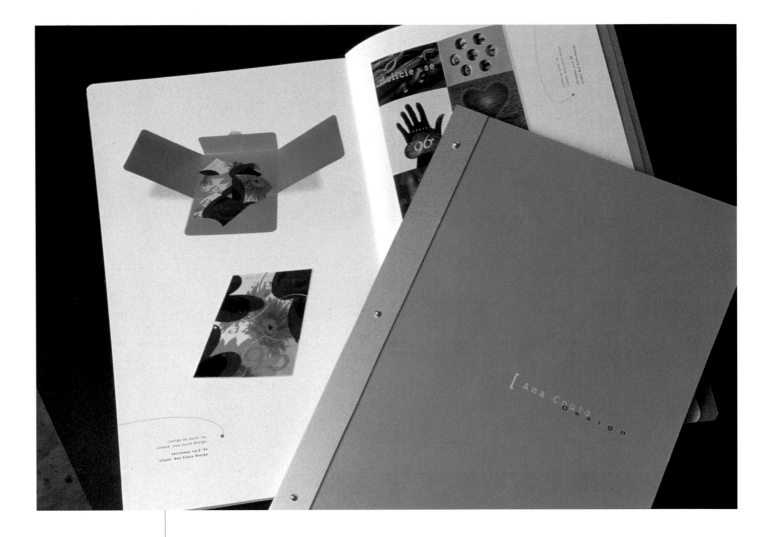

PROJECT> **Ana Couto Design Portfolio**
DESIGN FIRM/CLIENT> **Ana Couto Design,**
Rio de Janeiro, Brazil
ART DIRECTOR> **Ana Couto**
DESIGNERS> **Ana Couto,**
Natascha Brasil, Roberta Gamboa
PHOTOGRAPHER> **Pedro Lobo**

Parchment vellum inserts and heavy
bindery give this design studio portfolio
the appearance of a fine art book. The
simplicity of the interior allows the
work to stand out and speak for itself.

PROJECT> GE/GNA Market Solutions Posters
DESIGN FIRM> Hornall Anderson
Design Works, Inc.,
Seattle, Washington, USA
CLIENT> GE/GNA, Seattle, Washington, USA
ART DIRECTOR> Lisa Cerveny
DESIGNERS> Lisa Cerveny,
Jana Wilson Esser, Virginia Le
PHOTOGRAPHER> Robin Bartholick

Highly legible type laid over the strong lines, the light and shadows of a monolithic sculpture, and contrasting colors combine to form a classically crisp design solution. These two examples from Hornall Anderson also demonstrate the diversity that can be created within a tight visual theme.

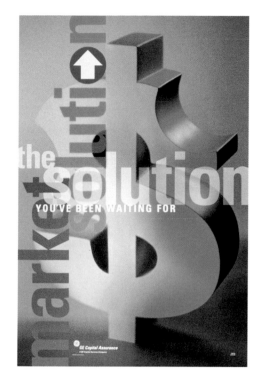

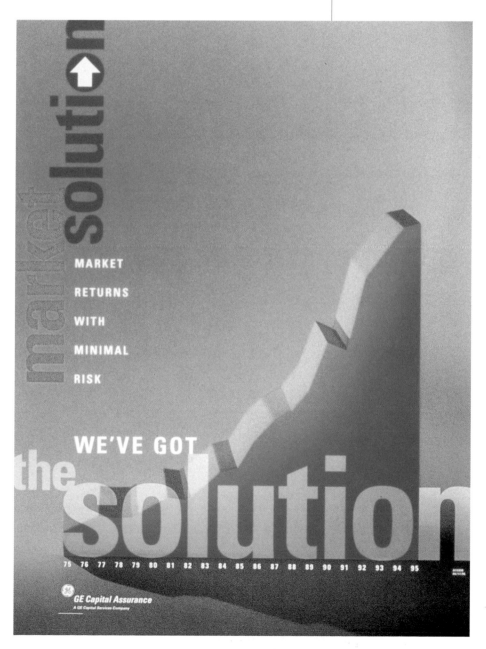

Think of dark. Basic black and a single strand of pearls might come to mind, but that is elegant. Dark design finds its roots in cinema noire, cinema vérité, surrealism, science fiction, and a touch of the macabre. Though black is the most predominant element, deep hues and heavy shadows can make nearly any color usable for dark design. Images can be drawn directly from early- or mid-twentieth-century sources. Hipper than hip, dark design is a hot trend that has had great fringe and counterculture appeal for ages.

"Clients and designers sometimes find it difficult to verbally communicate their desires or solutions because each believes they know good design."

James Lland,
Lland Graphics

sombre = finster = donker = escuro = oscu

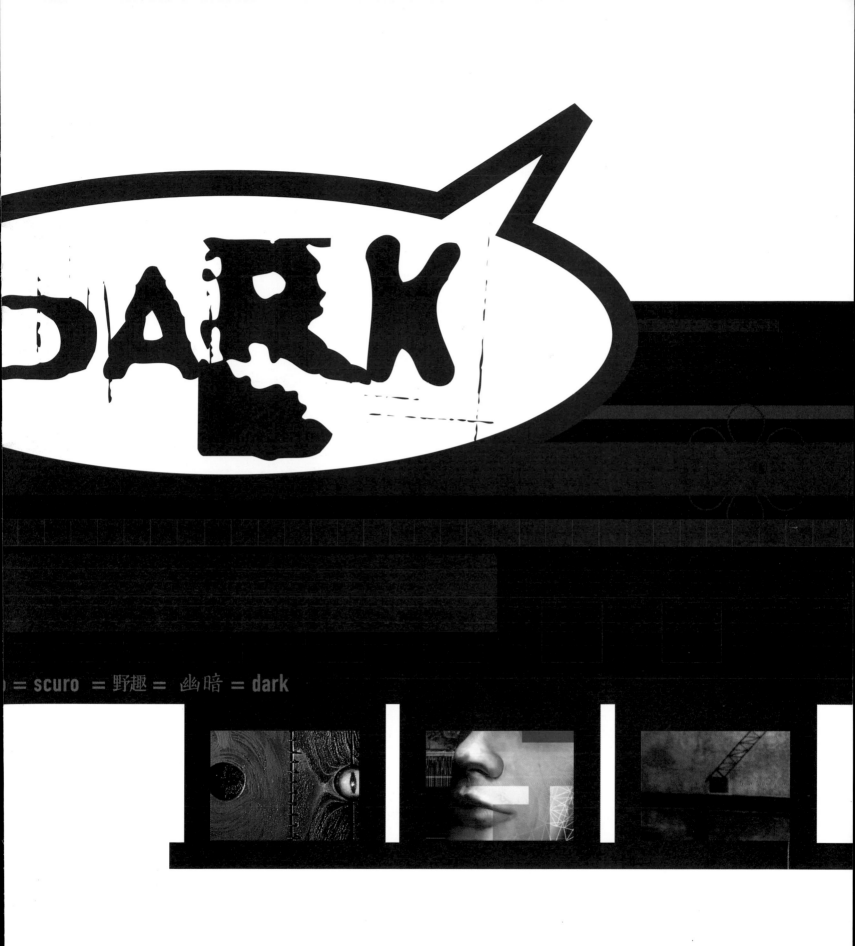

PROJECT> *Scar* Promotional Poster
DESIGN FIRM> Inkahoots Design,
Brisbane, Queensland, Australia
CLIENT> La Boite Theatre,
Brisbane, Queensland, Australia
ART DIRECTOR/DESIGNER> Jason Grant
ILLUSTRATOR> Donna Kendrigan

In this poster for a dark comedy at Brisbane's La Boite Theatre, with its burning type, touches of humor warm an otherwise eerie poster. The hint of a sweeping smile on the left side of the image also plays off the more somber right side. The two become the traditional faces of comedy and tragedy. This poster also demonstrates how, through proper juxtaposition, even common items, such as the corkscrew and can-opener handle, can look sinister.

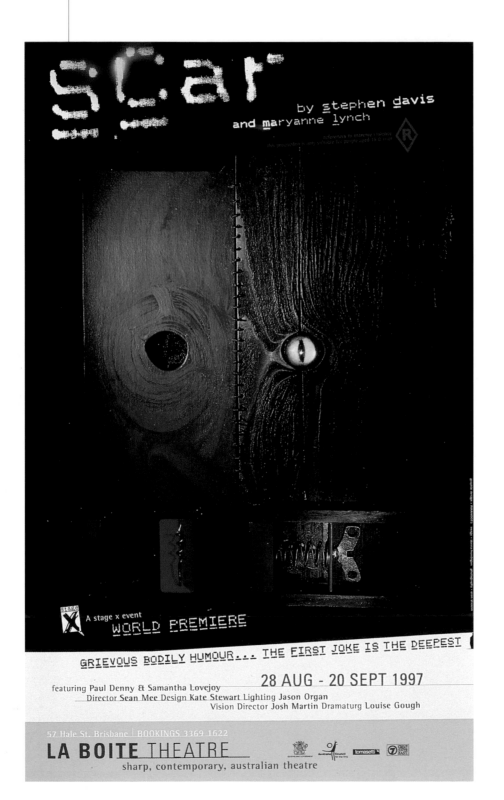

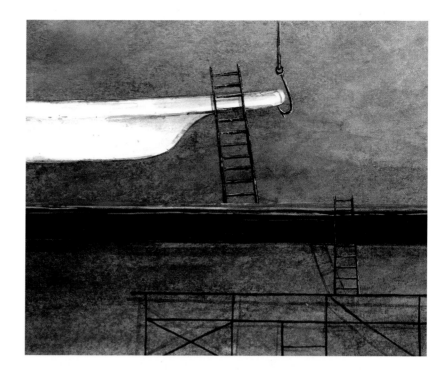

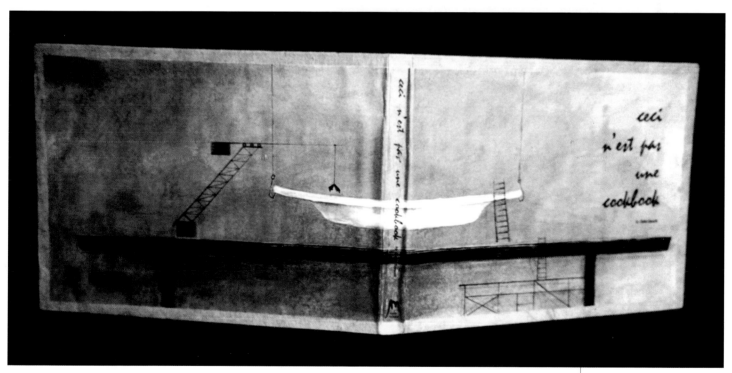

PROJECT> *Ceci N'Est Pas Une Cookbook*
Book Jacket
DESIGN FIRM> **Redesign,**
Edinburgh, Scotland
CLIENT> **Conceptual artwork**
ART DIRECTOR> **Regina Fernandes**
ILLUSTRATOR> **Regina Fernandes**

This cover for a surrealist cookbook, with its title twist on René Magritte's painting *Ceci N'Est Pas Une Pipe*, captures the dark humor of surrealism. The darkness appears here not only in the rich tones but also in the rickety ladders and scaffolding and the menacing fish hook.

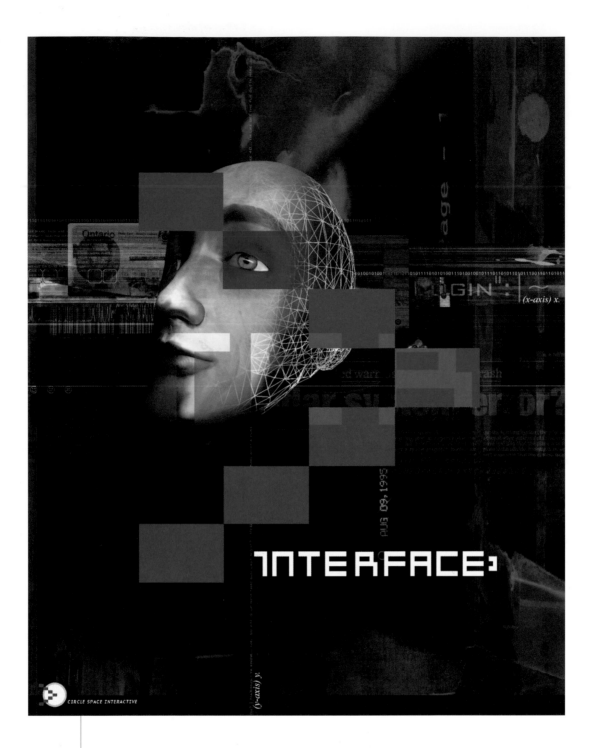

INTERFACE:

CIRCLE SPACE INTERACTIVE

PROJECT> Circle Space Interactive
Promotional Poster
DESIGN FIRM> Amoeba Corporation,
Toronto, Ontario, Canada
CLIENT> Circle Space Interactive,
Toronto, Ontario, Canada
DESIGNERS> Steve McArdle, Michael Kelar
3-D ILLUSTRATOR> Steve McArdle

Liberal use of dark backgrounds and subordinate imagery can turn a poster into a single-image gallery, as it does in this promotional piece for Toronto's Circle Space Interactive. The mix of fonts also gives this high-tech piece a timeless quality.

PROJECT> *Cantos* Book Jacket
DESIGN FIRM> Redesign, Edinburgh, Scotland
CLIENT> Interior Ediçoés,
Além Paraiba, Mina Gerais, Brazil
ART DIRECTOR> Regina Fernandes
ILLUSTRATOR> Regina Fernandes

This haunting book cover by Regina Fernandes gains its depth from a double entendre. The spilled ink becomes a nighttime sky that is as dark as ink. The result is a feeling of mystery.

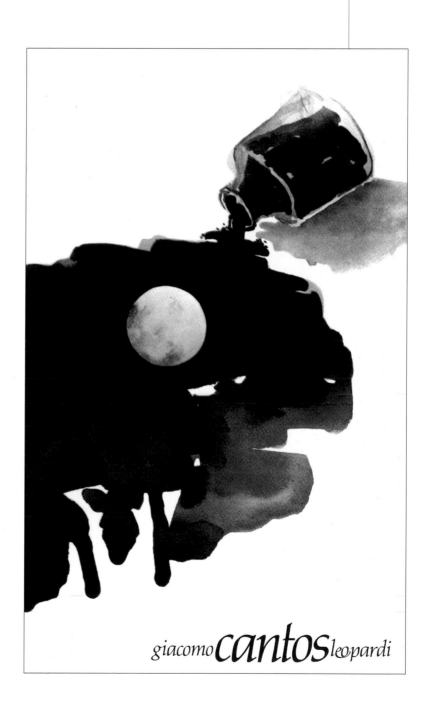

giacomo **Cantos** *leopardi*

PROJECT> Blender T-Shirts Logo
DESIGN FIRM> Amoeba Corporation,
Toronto, Ontario, Canada
CLIENT> Blender T-Shirts,
Vancouver, British Columbia, Canada
DESIGNER> Michael Kelar

Dark design can also be deconstructivist. The type in this logo shatters and dissolves, breaking out of its own frame. This post-grunge look in font design has seen a rapid rise in popularity as people discover the more advanced type-creation software tools, which allow savvy users to create intentionally flawed type with ease.

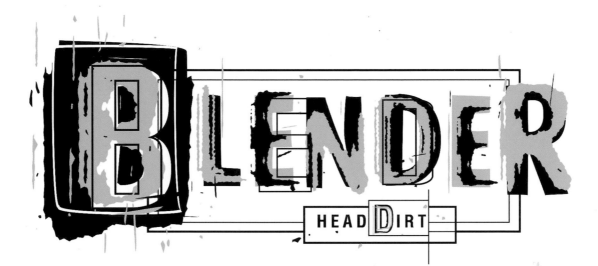

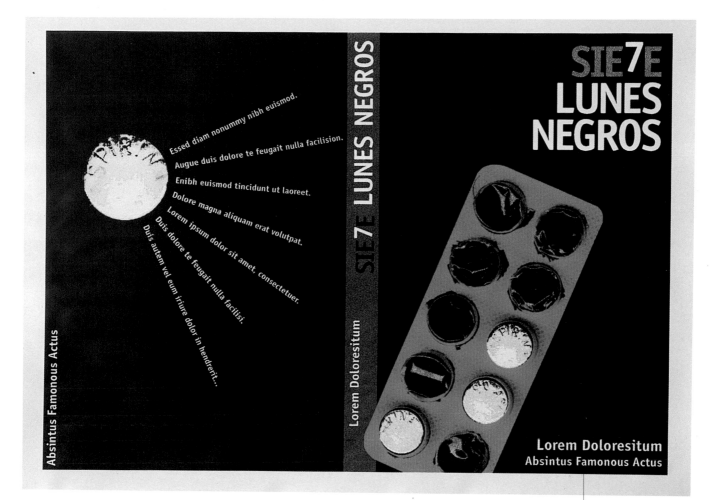

On the cover:

SIE7E LUNES NEGROS

Essed diam nonummy nibh euismod.

Augue duis dolore te feugait nulla facilision.

Enibh euismod tincidunt ut laoreet.

Dolore magna aliquam erat volutpat.

Lorem ipsum dolor sit amet, consectetuer.

Duis dolore te feugait nulla facilisi.

Duis autem vel eum iriure dolor in hendrerit...

Absintus Famonous Actus

SIE7E LUNES NEGROS

Lorem Doloresitum

Lorem Doloresitum
Absintus Famonous Actus

PROJECT> *Siete Lunes Negros* Book Design
DESIGN FIRM> Corh Consultores,
Madrid, Spain
CLIENT> Instituto Europeo di Design,
Madrid, Spain
ART DIRECTOR> Manuel Estrada
DESIGNER> Miguel Solak

The seven missing pills become seven black moons on this powerful cover created by Corh Consultores. The high-contrast imagery causes the aspirin themselves to take on the appearance of moons, complete with craters and other surface textures, while the back cover copy radiates around a single aspirin like moonbeams.

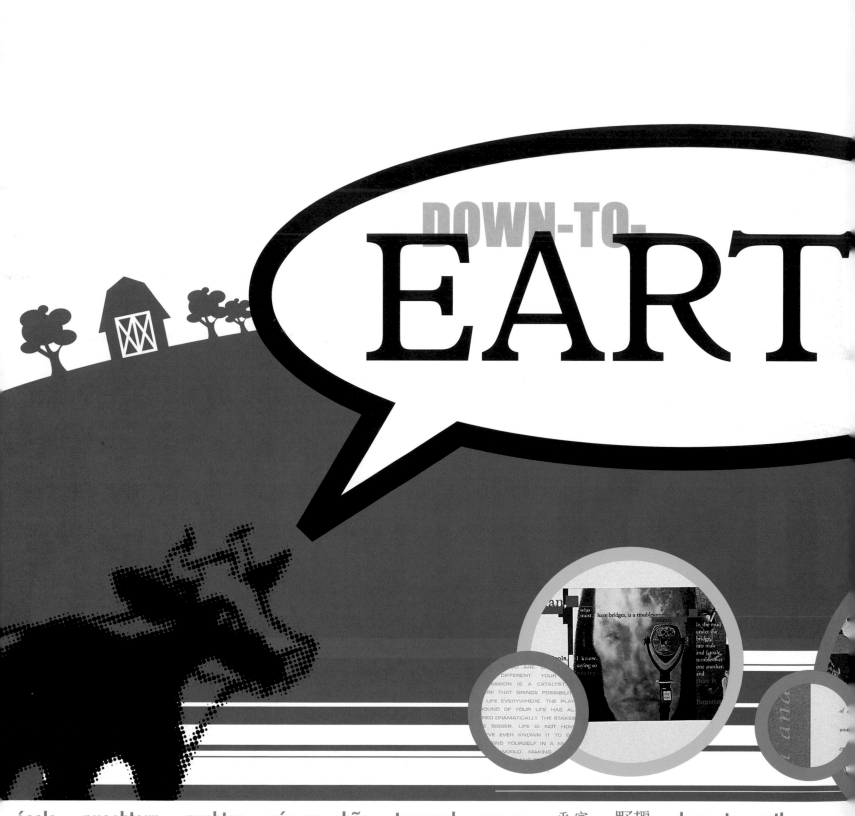

DOWN-TO-EART

écolo = nuechtern = nuchter = pés-no-chão = terrenal = grezzo = 平實 = 野趣 = down-to-earth

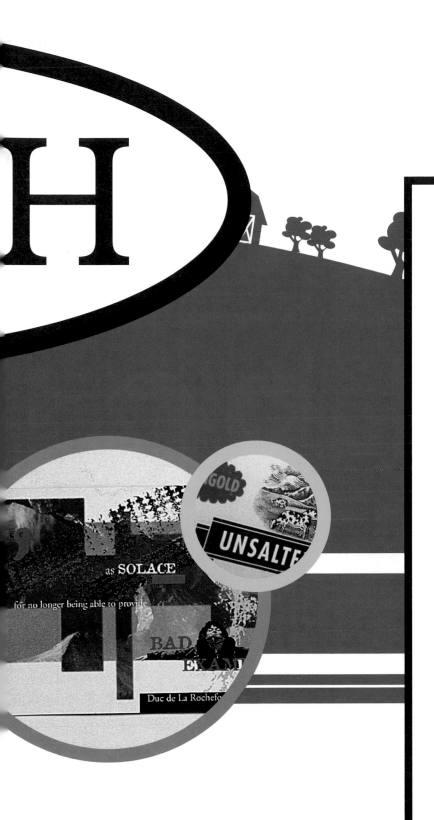

The down-to-earth approach is realistic and practical. Although a design solution that contains these qualities can also be urban and refined, it stays close to its robust and unaffected roots. A down-to-earth presentation takes a direct and sometimes gritty stance toward the communication of its message. It reaches viewers without complicated visual or text elements, instead seeking to apply the greatest common communication denominators. The color palette is not limited to earth tones but is driven by colors associated with the client. Where the client's visual identity employs bright or unnatural colors, a down-to-earth design solution might use one of these set in grayscale. Agricultural or pastoral icons such as farms, trees, and cows are common motifs in down-to-earth solutions, these can be used to humanize even high-tech products. A classic example is the packaging for Gateway Computers, which features a distinctive black-and-white cowhide print.

"I work most efficiently with clients who are able to give me an explicit concept to be represented. My usual tactic with an uncertain client is to say, "Let me produce some rough art and we'll take it from there." Once the client has something concrete to look at the process of refining graphic ideas moves ahead more rapidly."

James Peters,
Terrapin Graphics

LIBRARY & RESOURCES AREA - EPSOM CAMPUS

 THE SURREY INSTITUTE OF ART & DESIGN

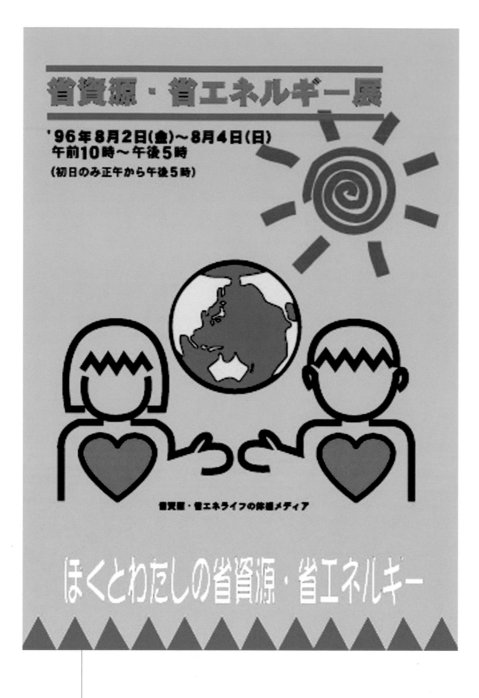

PROJECT> **Recycle and Save Energy**
Exhibition Poster
DESIGN FIRM> **Mihama Creative Associates,**
Yokohama, Japan
CLIENT> **Pleasure Seekers, Tokyo, Japan**
DESIGNER/ILLUSTRATOR> **Kimihiko Yoshimura**

These are simple images simply executed: a boy and a girl, the earth and the sun. The elements are reduced to the essential lines. The overall effect reaches out brightly beyond language barriers with its cheerful message of environmental awareness.

PROJECT> Terra Wine Labels
DESIGN FIRM> Barbara Harkness
Design Pty., Ltd.,
Adelaide, South Australia, Australia
CLIENT> Hollick,
Coonawarra, South Australia, Australia
ART DIRECTOR/DESIGNER> Barbara Harkness
ILLUSTRATOR> Clayton Glen

This may seem an obvious statement, but if a product name speaks to you, then listen to it. When Barbara Harkness created these wine labels, she avoided design conventions and pursued a concept reflecting the brand and its origins. Flourishes and gilding are notably absent. A more personal elegance rises from the central image's red earth and leaden sky, which is accented by the rough, deckled edges.

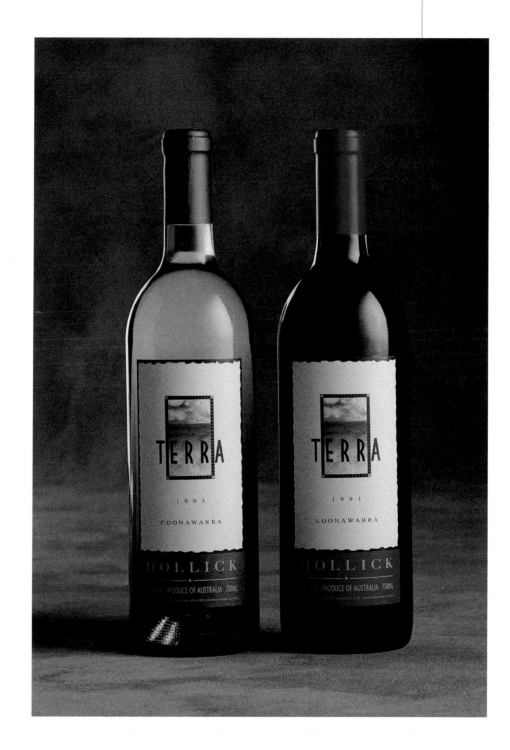

PROJECT> **Landmark Education
Corporation Brochure**
DESIGN FIRM> **Macnab Design
Visual Communications,
Albuquerque, New Mexico, USA**
CLIENT> **Landmark Education Corporation,
San Francisco, California, USA**
ART DIRECTOR/DESIGNER> **Maggie Macnab**
ILLUSTRATOR> **Brad Goodell**

As the designer explains, "The client really just let me go for it, but my first concept for the sequential illustrations was determined to be 'too new-agey.' " The eventual solution incorporated images that conveyed a rural, earthy atmosphere without going to extremes. Here, the common communication denominator was a well-executed application of a simplistic, childlike view of the world, carried through Macnab's illustrations and balanced by an earthy color palette.

Self Expression and Leadership

The Landmark Self-Expression and Leadership Program is designed to empower you in the expression of yourself and all that you create. It provides you with the know-how and power to establish an environment which invites and welcomes your self-expression and in doing so gives rise to the self-expression of others. ▪ ▪ ▪ Most of us think of self-expression as the ability to say in words or action what we think or feel. But authentic self-expression is never personal or conceptual; it happens only in relationship with others, in speaking and acting together. ▪ ▪ ▪ The Landmark Self-Expression and Leadership Program is for those ordinary people with commitments larger than themselves—people who have an opportunity to make a difference, to share what is possible in a way that forwards the freedom, magnanimity, and self-expression of others.

SO HERE YOU ARE. LIFE LOOKS PRETTY DIFFERENT. YOUR SELF-EXPRESSION IS A CATALYST, A SPARK THAT BRINGS POSSIBILITY TO LIFE EVERYWHERE. THE PLAYGROUND OF YOUR LIFE HAS ALTERED DRAMATICALLY. THE STAKES ARE BIGGER. LIFE IS NOT HOW YOU'VE EVER KNOWN IT TO BE. YOU FIND YOURSELF IN A MUCH BIGGER WORLD, MAKING A DIFFERENCE WITH AND TOUCHING THE LIVES OF THOSE AROUND YOU. THERE IS NO TURNING BACK, AND NOTHING IS EVER QUITE THE SAME.

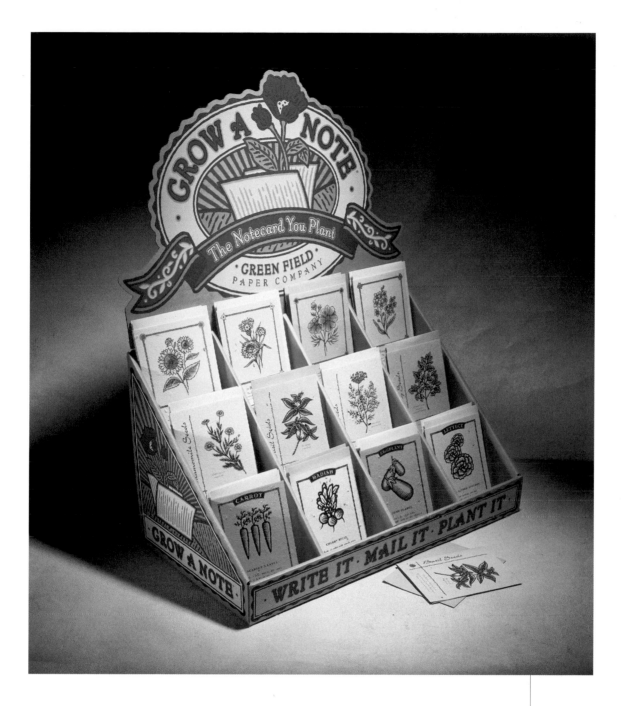

PROJECT> Grow a Note Point-of-Purchase Display

DESIGN FIRM> Mires Design, Inc.,
San Diego, California, USA

CLIENT> Green Field Paper Company,
San Diego, California, USA

ART DIRECTOR> José A. Serrano

DESIGNERS> José A. Serrano,
Deborah Hom, Mary Pritchard

ILLUSTRATORS> Fiona King, Tracy Sabin

These inexpensive notecards have a dual purpose, making them more cost-effective. The cards have seeds embedded in the fiber. The recipient plants the notecard, which grows into the plant pictured on the card's face. The down-to-earth visual elements convey warmth and a rural atmosphere to consumers.

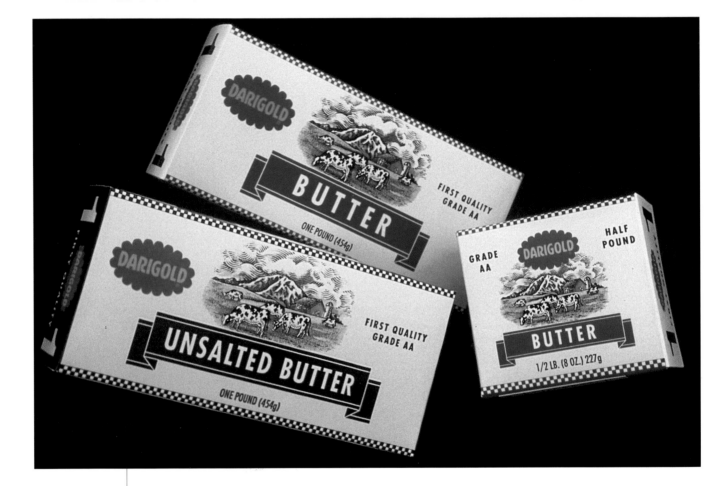

PROJECT> Darigold Corporation
Butter Packaging
DESIGN FIRM> Hornall Anderson
Design Works, Inc.,
Seattle, Washington, USA
CLIENT> Darigold Corporation,
Seattle, Washington, USA
ART DIRECTOR> John Hornall
DESIGNERS> John Hornall, Jana Nishi,
Debra McCloskey, Mary Chin Hutchison,
Leo Raymundo
ILLUSTRATOR> Carolyn Vibbert

While designers make their careers through innovative thinking and rule breaking, at times great design can be produced only by heeding convention. In butter packaging, for example, colors take on specific meanings (red for salted, blue for unsalted). This Darigold butter packaging meets that specification, then employs a pastoral illustration as a subtle statement about the product's quality and freshness.

PROJECT> **Promotional Material**
DESIGN FIRM/CLIENT> **Terrapin Graphics,**
Toronto, Ontario, Canada
ART DIRECTOR/DESIGNER> **James Peters**
ILLUSTRATOR> **James Peters**

Beyond the subtle, creative metaphor of the clay on the front becoming the brick on the back, the images Terrapin Graphics selected to show their illustrative, computer graphics, and design capabilities in this brochure are down to earth, human.

élégant = elegant = sierlijk = elegante = 高貴 = 雅びた

Taste and refinement are the key elements that make a design solution appear elegant. Like a graceful gesture or movement, an elegant form can speak volumes about the product's or service's attitude and origins. Elegance, to some people, implies an object or image that is ornate and embellished; to others, however, elegance is more frequently found in simplicity. An elegant palette is wide but muted. It can run from pastels to deep tones of burgundy, midnight blue, even brown. However, it is never brash. Neons, fluorescents, and other hot colors normally do not convey a feeling of elegance. Display and text fonts can range from elaborate script faces to refined serif faces, as long as the body text remains highly legible.

"To communicate the look and feel of a design, I think that understanding what your client wants is important and so is understanding their audience."

Elizabeth Draht,
Grafik Communications

legant

PROJECT> **Wedgwood Identity**
DESIGN FIRM> **The Partners,**
London, England
CLIENT> **Wedgwood,**
Stoke-on-Trent, England
PROJECT DIRECTOR> **Charlotte Blackburn**
ART DIRECTOR> **Aziz Cami**
DESIGNER> **Nina Jenkins**
ILLUSTRATOR> **Michael Pratley**

Wedgwood's new brand identity—described by creative director Jill Sharrock as "simple classicism in a modern idiom"—responds to the move away from formal dining toward more casual home entertaining. This rebranding exemplifies the difference between ornate and simple elegance, richness with and without embellishment. It is worth noting that consumer preferences with respect to degrees of decoration have been cycling for centuries.

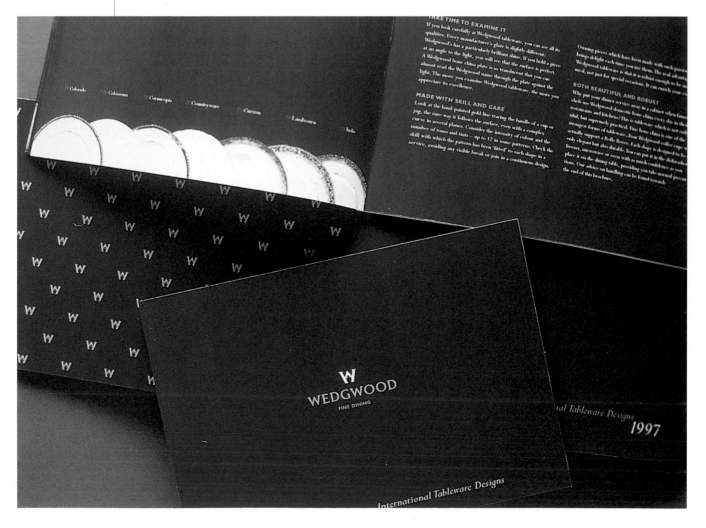

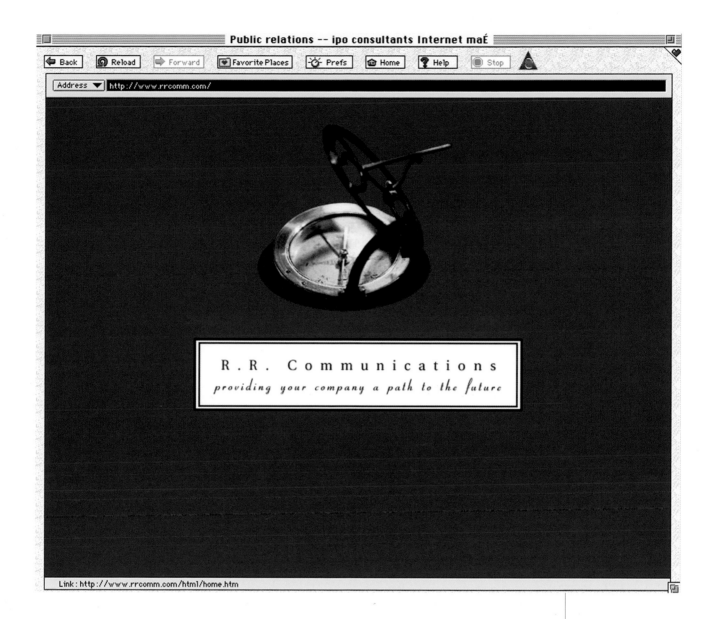

Within the browser window:

Public relations -- ipo consultants Internet maÉ

Back | Reload | Forward | Favorite Places | Prefs | Home | Help | Stop

Address ▼ http://www.rrcomm.com/

R.R. Communications
providing your company a path to the future

Link: http://www.rrcomm.com/html/home.htm

PROJECT> **R.R. Communications Web Site**
(www.rrcomm.com)
DESIGN FIRM> **Bo2 Productions,**
North Vancouver, British Columbia, Canada
CLIENT> **R.R. Communications,**
Vancouver, British Columbia, Canada
ART DIRECTOR/DESIGNER> **Boris Chow**

An ornate brass compass, a framed plaque, and deep-red background color—these elements would look right at home on a turn-of-the-century ocean liner, or even aboard the Orient Express. This opening screen has only two elements, yet it speaks volumes about the company.

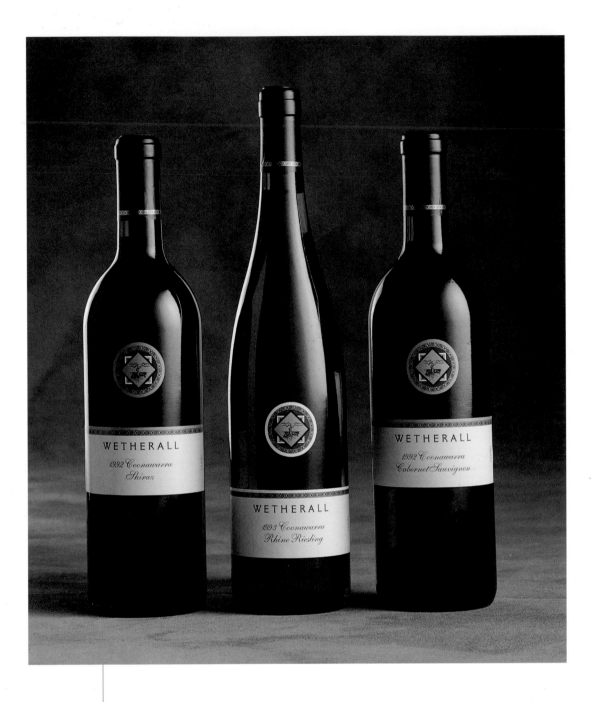

PROJECT> **Wetherall Wine Labels**
DESIGN FIRM> **Barbara Harkness**
Design Pty., Ltd.,
Adelaide, South Australia, Australia
CLIENT> **Wetherall,**
Coonawarra, South Australia, Australia
ART DIRECTOR> **Barbara Harkness**
ILLUSTRATOR> **Clayton Glen**

Though these wine labels are radically different from those the Harkness design team created for other wineries, they are no less elegant. Here, Harkness uses the primary colors of elegance: burgundy, royal purple, forest green, and gold on black, with parchment as the base. The overall effect is an unparalleled richness.

PROJECT> *Jazz* CD Cover and Insert
DESIGN FIRM> Redesign,
Edinburgh, Scotland
CLIENT> Conceptual artwork
ART DIRECTOR> Regina Fernandes
ILLUSTRATOR> Regina Fernandes

Fine art can lend an elegant touch to nearly any design, but there are ways to carry this concept even further. Here, abstract watercolor illustrations adorn the packaging for a jazz CD. The case itself is made of heavyweight cotton paper with deckled edges. The overall effect is that the CD is folded into a work of art (which, especially for jazz, far surpasses a standard jewel case).

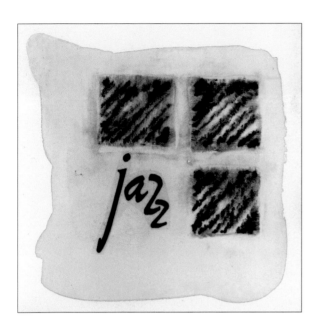

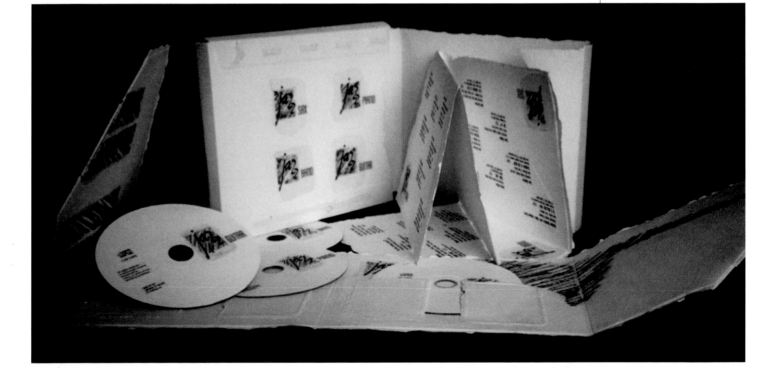

PROJECT> **Altus Metal and Marble**
Maintenance Brochure
DESIGN FIRM> **Lieber Brewster Design, Inc.,**
New York, New York, USA
CLIENT> **Altus Metal and Marble Maintenance,**
New York, New York, USA
ART DIRECTOR/DESIGNER> **Anna Lieber**
PHOTOGRAPHERS> **Wade Zimmerman,**
Don Brewster

The client wanted a classy look—a glossy brochure that would show the high quality and professionalism of the company's workmanship—so Anna Lieber decided to lead the reader in with an intriguing opening line, one that enticed the person to open the brochure. The visual elements—ornate stonework and gold tones opening to a dark, rich color palette and elegant images—conveyed the polished appearance desired by the client.

A commitment to excellence
Altus retains a staff of highly-skilled metal and marble tradesmen to ensure that your projects receive the quality service and the dependable follow-up you expect.

Hands-on supervision
Employing a time-tested apprenticeship system, projects are carefully supervised for consistent quality control during all phases of the project.

Responsive Service
Attention to high quality workmanship and service is always a priority at Altus. When unusual needs arise, Altus is known for decisive response. After the 1993 bombing of the World Trade Center, we were awarded the contract to perform the challenging restoration to the metal and marble damaged in the explosion. The project was completed in record time, while receiving our usual attention to detail.

OSHA-certified safety officer
An on-staff consultant performs regular inspections and leads in-service education to ensure the highest safety standards.

Masterful results, competitive pricing
We work closely with architectural and engineering professionals on all projects to achieve high-level results in aesthetics and function. Contractors, metal fabricators and real estate professionals know Altus for reliable service at honest, competitive pricing.

Altus Metal
& Marble
Maintenance

7 Brookview Court
Stony Brook, NY 11790
212 629-1089 • 516 689-9111
516 689-9114 fax

Servicing the NY metropolitan
and tri-state areas.

Call for a free evaluation,
proposal and updated client list.

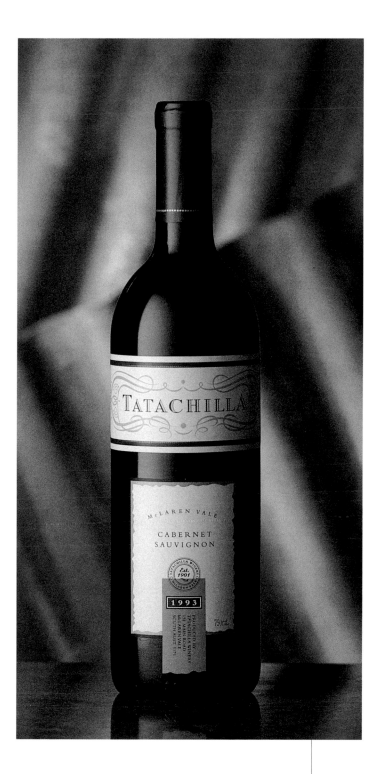

PROJECT> Tatachilla Wine Labels
DESIGN FIRM> Barbara Harkness
Design Pty., Ltd.,
Adelaide, South Australia, Australia
CLIENT> Tatachilla,
McLaren Vale, South Australia, Australia
ART DIRECTOR> Barbara Harkness
ILLUSTRATOR> Clayton Glen

Flourishes and outlined type are traditionally elegant touches. Here, they are given modern interpretations, making them fresh and soft. But elegance can also convey authority and quality. The circular marks on the wine labels look like traditional seals of approval. This is not misleading and is, in fact, an effective way to brand products with a show of pride.

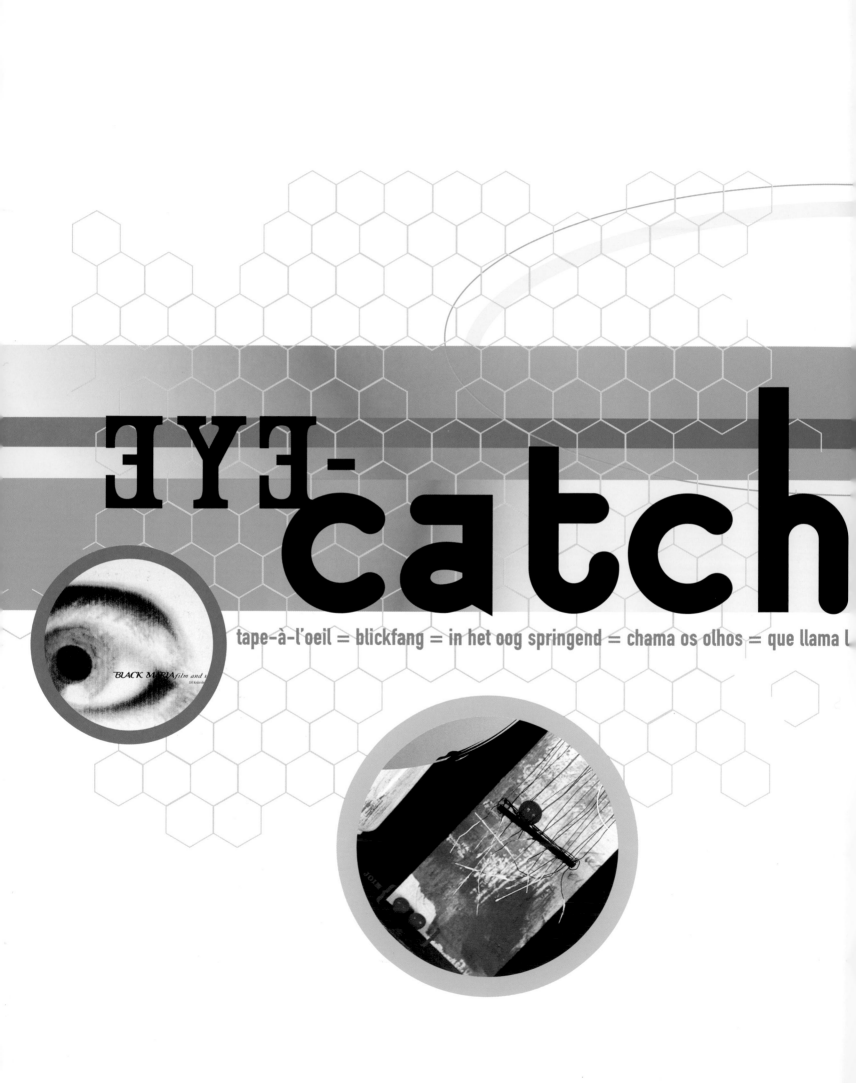

EYE-catch

tape-à-l'oeil = blickfang = in het oog springend = chama os olhos = que llama l

ing

tención = notevole = 奪目 = 女らしい = eye-catching

When the visual presentation speaks louder than the words of a message, the design is eye-catching. If it makes the viewer stop and take notice by its portrayal of a bold image, use of vivid colors, or unconventional approach, the design accomplishes its mission.

The visual element in a design solution that catches viewers' attention is the hook. Every good design has a hook. The difference between a design and an eye-catching design is the difference between a fly-fishing hook and a shark hook. If a client wants something eye-catching, avoid subtleties. Shun big blocks of small text. Pass on conglomerations of small mono-tone or duotone images. These are great backgrounds for eye-catching design and can serve as eye-holding elements, which are as important to a design as a snell or barb is on a hook.

"Think of the solution as a sound or a physical sensation. Visualize the gasp of surprise, the anticipation of goose bumps, and the fixed stare of excitement. Juxtapose human emotions and senses by assigning one as image and one as type."

Martha Carothers,
University of Delaware

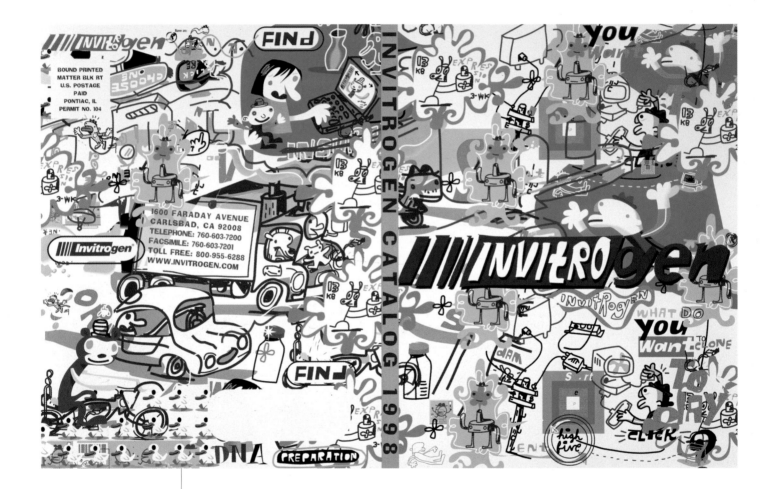

PROJECT> Invitrogen Corporation
1998 Catalog
DESIGN FIRM> Mires Design, Inc.,
San Diego, California, USA
CLIENT> Invitrogen Corporation,
Carlsbad, California, USA
ART DIRECTOR> José A. Serrano
DESIGNERS> José A. Serrano,
Mary Pritchard
ILLUSTRATOR> J. Otto Siebold

The client wanted an eye-catching cover for it's catalog, so the design team applied a fresh look that wasn't too high-tech in its approach. Illustrator J. Otto Siebold's unpolished and cartoonish style is highly entertaining, especially in full color, and draws viewers' attention. The high contrasts, frenetic visual motion, and fast-reading text pull viewers to the image and hold them there.

PROJECT> HDTV Package
DESIGN FIRM> Grafik Communications,
Alexandria, Virginia, USA
CLIENT> Harris/PBS DTV Express,
Alexandria, Virginia, USA
DESIGNERS> Johnny Vitorovich,
Garth Superville, Gregg Glaviano,
Judy Kirpich

The designers put themselves in the end-users' place in order to create an eye-catching piece that was both functional and engaging. The strong contrasts of traditional television pixel colors direct viewers' focus to the center of the image. The display text stands out despite its small size because it is in uncluttered space. The small title text makes for a smooth transition to the text inside the package.

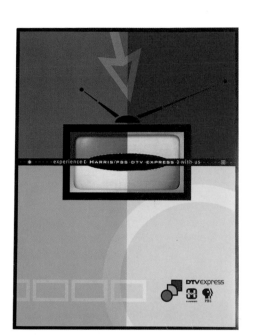

PROJECT> Totsuka Community
Forum Poster and Leaflet
DESIGN FIRM> Mihama Creative Associates,
Yokohama, Japan
CLIENT> Yokohama City, Totsuka Ward
Office Public Relations Division,
Yokohama, Japan
DESIGNER> Kimihiko Yoshimura

While Westerners often perceive their style as minimalist and delicate, Japanese designers produce a wide range of eye-catching art. On the crowded streets of Japan's major cities, images vie for attention. Ultrabold text is knocked out of bright-colored boxes and set on vivid backgrounds. Pertinent information is in huge type; one can get the necessary information at a glance and stop for more if desired.

PROJECT> **Queensland Writers Center Poster**

DESIGN FIRM> **Inkahoots Design, Brisbane, Queensland, Australia**

CLIENT> **Brisbane Writers Center, Brisbane, Queensland, Australia**

ART DIRECTOR/DESIGNER> **Jason Grant**

ILLUSTRATOR> **Donna Kendrigan**

The peeling paint and implied bare floor of this found-materials multimedia background sculpture are allowed to stand out in this poster by minimalist type treatment. A simple question, without embellishment, provides an effective hook to grab the attention of the target audience.

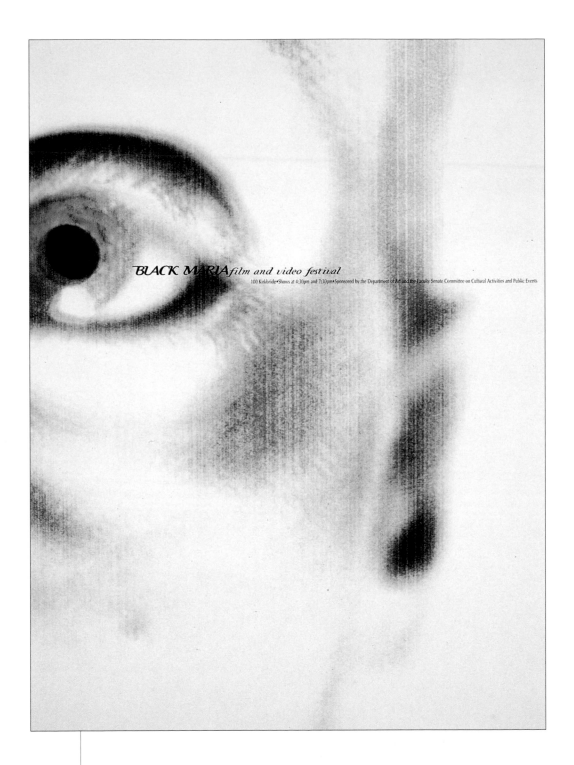

BLACK MARIA film and video festival
100 Kirkbride•Shows at 4:30pm and 7:30pm•Sponsored by the Department of Art and the Faculty Senate Committee on Cultural Activities and Public Events

PROJECT> **Black Maria Film and Video Festival Poster**
DESIGN FIRM> **University of Delaware Department of Art, Newark, Delaware, USA**
CLIENT> **University of Delaware, Newark, Delaware, USA**
DESIGNERS> **Martha Carothers, Raymond Nichols, Hendrik-Jan Francke, Melissa Fritz, Michael Gettings, Thomas Jones, Brittney Singletary**
PHOTOGRAPHER> **Sherry Heck**

The client said, "Show a visual reaction from the audience," so the designers conceived of a solution conveying a sound or a physical sensation. They juxtaposed human emotions and senses by assigning one as image and one as type. Every time the number of elements is reduced, the impact of each element is increased, either in size, as with images, or by decreased competition for attention, as with text.

PROJECT> **Not Yet Famous Artists Revealed Student Exhibition Poster**
DESIGN FIRM> **University of Delaware Department of Art, Newark, Delaware, USA**
CLIENT> **University of Delaware, Newark, Delaware, USA**
DESIGNERS> **Martha Carothers, Raymond Nichols, Hendrik-Jan Francke, Scott Ratinoff, Brittney Singletary, Preston Thomas**
PHOTOGRAPHER> **Sherry Heck**

The client said, "Take a 'how did you shoot it?' photograph. No Photoshop retouches, please." The designers set up the shoot with a number of typographic solutions, then they made one last photographic experiment. This final image was the one ultimately selected because its spontaneity was coaxed from the predetermined photographs. Sometimes experimentation and spontaneity can produce eye-catching results by taking advantage of viewers' curiosity.

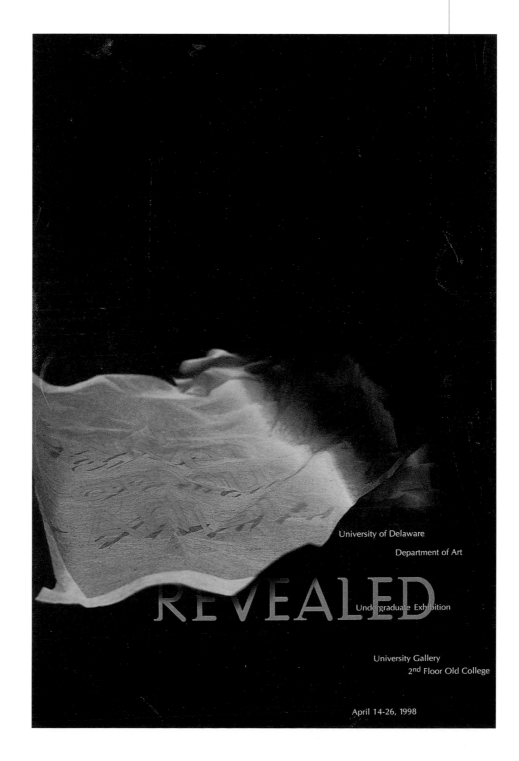

fe

Webster's dictionary defines the word feminine as "having qualities traditionally ascribed to women, as sensitivity or gentleness." In design, feminine attributes include softer tones, lighter colors, delicate serif or script typefaces, and genteel imagery. This design style is applicable not only when the target audience is predominantly female, but also when the client wants a nurturing, caring, or gentle design solution. For example, this is a common mode for health-care products and services such as HMOs, pharmaceuticals, and long-term care centers.

"Cultural differences usually don't change the word clean or feminine, but do change words like sophisticated and innovative. What is innovative today? Innovative contemporary? Innovative vanguard? Innovative grunge? Innovative techno?"

Rafael Peixoto Ferreira,
Rafa Ferreira Design

minine

féminin = weiblich = vrouwelijk = feminino = femminile = 女性化 = 女らしい = feminine

PROJECT> **1998 Calendar Design**
DESIGN FIRM/CLIENT> **Redesign,**
Edinburgh, Scotland
ART DIRECTOR> **Regina Fernandes**
ILLUSTRATOR> **Regina Fernandes**

Even images that are not considered feminine—such as this ant—can be imbued with feminine qualities. Success depends on the medium and the execution, as in this self-promotional calendar.

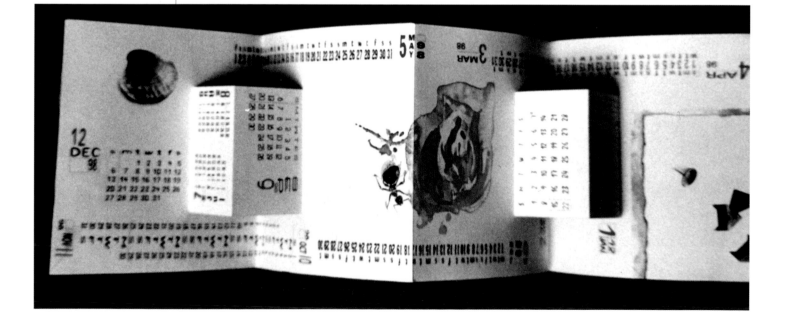

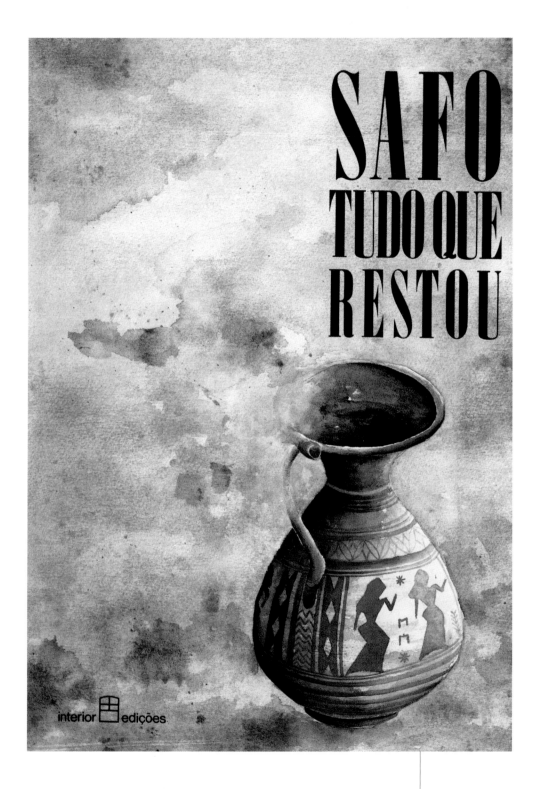

SAFO TUDO QUE RESTOU

interior edições

PROJECT> ***Todo Que Restou***
(Sappho) Book Jacket Design
DESIGN FIRM> Redesign,
Edinburgh, Scotland
CLIENT> Interior Ediçoés,
Além Paraiba, Minas Gerais, Brazil
ART DIRECTOR> Regina Fernandes
ILLUSTRATOR> Regina Fernandes

The images of two women on a Grecian vessel (carrying water and pouring wine are tasks archaically associated with women) and the soft watercolor background add subtle femininity to this book jacket.

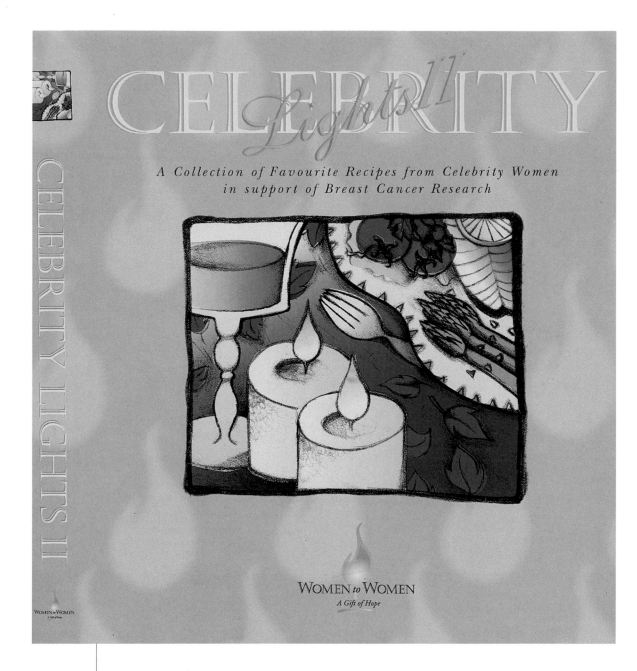

CELEBRITY LIGHTS II

CELEBRITY *Lights II*

A Collection of Favourite Recipes from Celebrity Women
in support of Breast Cancer Research

WOMEN *to* WOMEN
A Gift of Hope

PROJECT> **Celebrity Lights Foundation
Cookbook Design**
DESIGN FIRM> **Neo-Graphic Communications,
Nanaimo, British Columbia, Canada**
CLIENT> **Celebrity Lights Foundation,
Nanaimo, British Columbia, Canada**
ART DIRECTOR/DESIGNER> **Valerie Luedke**
ILLUSTRATOR> **Valerie Luedke**
PHOTOGRAPHER> **Kim Stallnecht**

The script, outlined serif, and light italic fonts, the peach-toned background, and the pastel and charcoal sketch combine to form a legible and feminine design for this cookbook cover. The style is especially appropriate as the cookbook was created for a breast cancer fundraiser.

PROJECT> Free Jazz Pack Collection
DESIGN FIRM> Ana Couto Design,
Rio de Janeiro, Brazil
CLIENT> Souza Cruz, Rio de Janeiro, Brazil
ART DIRECTOR> Ana Couto
DESIGNERS> Ana Couto, Natascha Brasil,
Cristiana Nogueira, Jacqueline Fernandez,
Tim Hussey, Gina Binkley
ILLUSTRATORS> Russelo Jones, Elizabeth
Rosen, Beppe Giacobbe

Designed for the 1998 Free Jazz Festival in Rio de Janeiro, this upbeat cigarette packaging design and accompanying promotional campaign feature festive colors and free-spirited images as well as lines and shapes filled with sensuous curves.

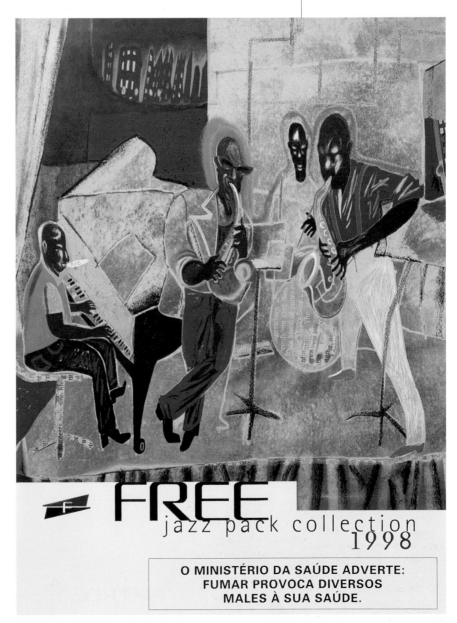

HIP AND t.

cool et branché = hip und trendig = hip en trendy = hip = franco e che segue le tendenze di moda

APPETIZERS

trendy

時宜 ＝ ナウ ＝ hip and trendy

When a design solution conveys the message that both designer and client are familiar with the latest styles or concepts, it's hip. However, hipness takes more than keeping an eye on the trends. For example, a hip person wouldn't have been caught dead sitting in front a computer monitor pursuing an essentially nonsocial activity thirty years ago. That was the exclusive realm of pasty-faced people with plaid shirts and plastic pocket liners for their pens and pencils. Today, of course, computer nerds are the hippest segment of the population and in all likelihood they will remain so until the day they label themselves hip—which, as Virgin Records founder Richard Branson points out—is truly unhip. So what is hip? A few elements have stood the test of time: black clothes, motorcycles, sunglasses, many forms of music, surfing, drinking, smoking, rebellion—just to name a few.

"I think designers should use more of their skills—writing words, drawing sketches, etc.—to understand concepts and create concrete images of the client's thoughts."

Kimihiko Yoshimura,
Mihama Creative Associates

PROJECT> **Fuse 1995 Web Site
(www.fontshop.de/fuse95)**
DESIGN FIRM> **U.R.L. Agentur für
Informationsdesign GmbH,
Vienna, Austria**
CLIENT> **FontShop Germany,
Berlin, Germany**
ART DIRECTOR/DESIGNER> **Tina Frank**
ILLUSTRATOR> **Neville Brody**
ANIMATOR/PROGRAMMER> **Andreas Pieper**

The annual Fuse conference is to type
what Paris couture shows are to fashion.
It attracts cutting-edge designers,
established commercial type designers,
and futurists whose visionary work
will launch new generations of func-
tional type. The Fuse Web site needed
to reflect these styles. Its designers
succeeded by placing oversized, incon-
gruous font samples in many hues
on black backgrounds; these works
thus need not compete with a highly
embellished site.

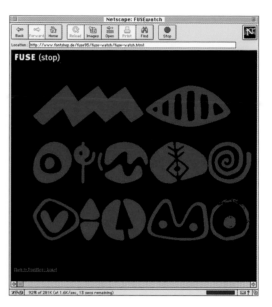

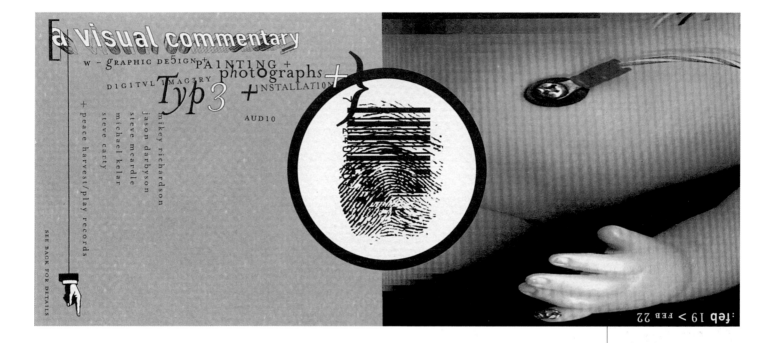

PROJECT> **Shift F5 Invitation and Logo**
DESIGN FIRM> **Amoeba Corporation,**
Toronto, Ontario, Canada
CLIENT> **Shift F5-**
Contemporary Art and Design Exhibit,
Toronto, Ontario, Canada
ART DIRECTOR> **Michael Kelar**
DESIGNERS> **Michael Kelar, Jason Darbyson**
BABY MAKER> **Steve McArdle**

This art show invitation catches the event's feel of past and futurist work, presenting it with hip elements. The fingerprint and the barcode represent past and future methods of identification. The barcode itself carries classic counter-culture messages. Also, stylized imagery of babies has been in since the 1920s. Recent generations' visuals include Keith Haring's babies and the cover baby on Nirvana's self-titled album.

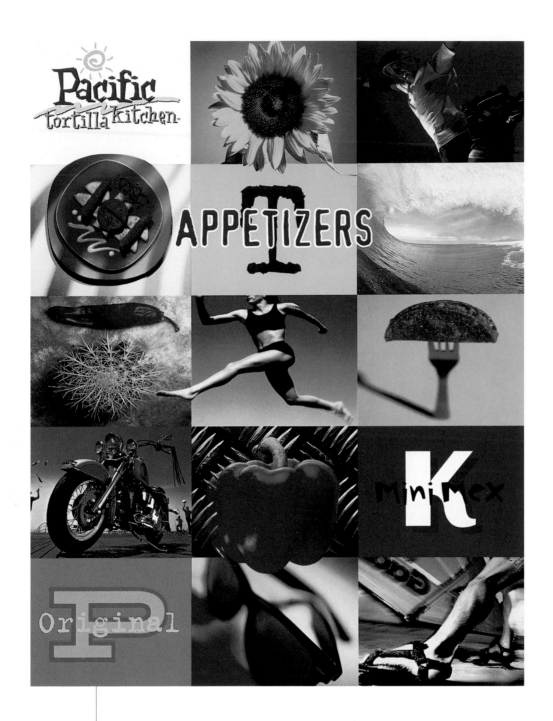

To capture the excitement and flavor of the hottest food sensation—wraps—the design team focused on the client's directive to make a hip brochure presentation. They succeeded by incorporating a variety of timely and timeless icons of hipness in a dynamic format, using modern type treatments to continue the visual effect through the text sections.

PROJECT> **Pacific Tortilla Kitchen Wraps Brochures**
DESIGN FIRM> **Mires Design, Inc., San Diego, California, USA**
CLIENT> **Food Group, Westlake Village, California, USA**
ART DIRECTOR> **Scott Mires**
DESIGNERS> **Scott Mires, Deborah Hom**
PHOTOGRAPHERS> **Various**

PROJECT> **Maryland Institute College of Art Catalog**
DESIGN FIRM> **Grafik Communications, Alexandria, Virginia, USA**
CLIENT> **Maryland Institute College of Art, Baltimore, Maryland, USA**
DESIGNERS> **Gregg Glaviano, Lynn Unemoto, Judy Kirpich**
PHOTOGRAPHERS> **Joe Rubino, Dan Meyers**

To create this art-school catalog, the designers concentrated their energies on the client's directive to make the project look hip. They also focused on three commandments: "Know your audience. Do your homework. Then, have fun." Images by the students and of the students were a natural source of hip imagery. The wide variety of page layouts possible in this very flexible design maintains the pace throughout this book-sized catalog.

PROJECT> **Paper Chase Printing Promotional Brochure**
DESIGN FIRM> **Hal Apple Design, Manhattan Beach, California, USA**
CLIENT> **Paper Chase Printing, Los Angeles, USA**
ART DIRECTOR> **Hal Apple**
DESIGNER> **Karen Walker**

Told to do whatever they liked, the Hal Apple design team created a hip solution for this southern-California printing firm. Familiar items (few pictures catch people's attention as consistently as images of money or of a person's eyes) set in arrays of blazing colors have an arresting effect and provide an engaging sample of the printers' talent.

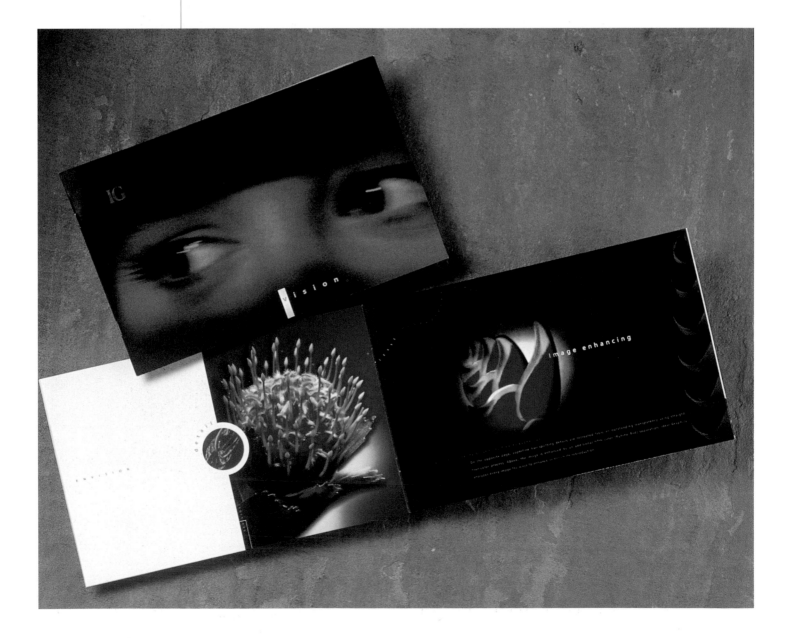

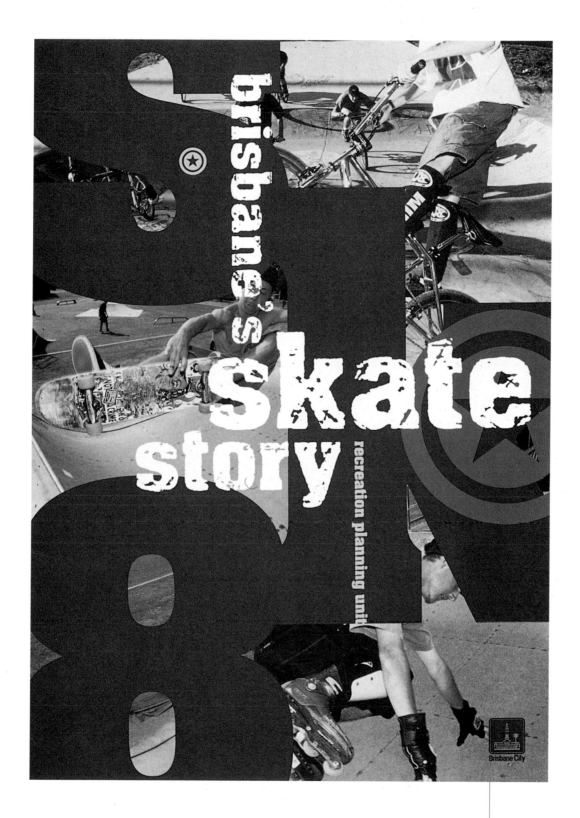

PROJECT> Brisbane's Skate
Story Report Design
DESIGN FIRM> Inkahoots Design,
Brisbane, Queensland, Australia
CLIENT> Brisbane City Council,
Brisbane, Queensland, Australia
ART DIRECTOR/DESIGNER> Steve Alexander

This report for the Brisbane, Australia, Recreation Planning Council takes a cue from urban tagging. The background images also play an essential part, setting the tone and allowing signs like Skateboarding Is Not a Crime to show through.

sincère = ehrlich = eerlijk = honesto = honrado = onesto = 眞誠

h

Strange as it might seem, honesty is not automatic in graphic design. Nothing is presented "as is." At the very least, visual presentations of clients' products and services reflect the designer's perception, but even more often, presentations are stylized to play up certain elements or to communicate a desired underlying message. If the message is honesty, the design solution must seek to present clients as they are, without embellishment. Handwriting fonts, photos of real people, and pictures of products in use or employees at work all communicate honesty. The color palette can be bright or subdued, but extremes of either direction should be avoided.

"I always try to ask as many questions as possible so we can get as close as possible to a common understanding. If that fails I do some quick sketches. Isn't a picture worth a thousand words?"

Regina Fernandes,
Redesign

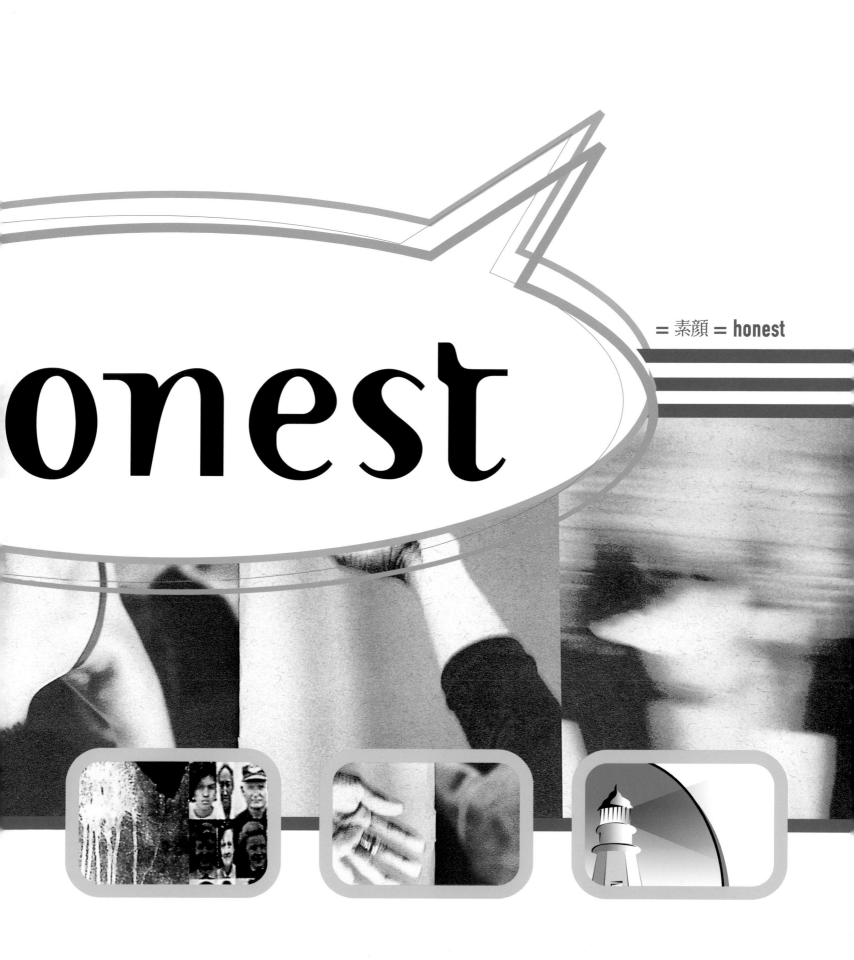

onest

= 素顔 = honest

Westfalia *Wärmetechnik*
Heinrich Schröder GmbH

PROJECT> **Westfalia Wärmetechnik Heinrich Schröder GmbH Corporate Design**
DESIGN FIRM> **Dirk Rullkötter AGD (Advertising + Design), Kirchlengern, Germany**
CLIENT> **Westfalia Wärmetechnik Heinrich Schröder GmbH, Bünde, Germany**
ART DIRECTOR/DESIGNER> **Dirk Rullkötter**

Logos are design solutions that are stripped down to essentials; this emblem communicates the essence of honesty. Combining blue—the first color of corporate design—with highly legible uppercase and lowercase characters, this logo completely avoids pretension.

PROJECT> **Huron Physical**
Rehabilitation Corporate Identity
DESIGN FIRM> **Neo-Graphic Communications,**
Nanaimo, British Columbia, Canada
CLIENT> **Huron Physical Rehabilitation,**
Goterich, Ontario, Canada
ART DIRECTOR/DESIGNER> **Valerie Luedke**
ILLUSTRATOR> **Valerie Luedke**

Canadian designer Valerie Luedke maintains a tradition in health-services iconography by employing a symbol of strength: in this case, a lighthouse, which is a strong image of help, safety, and security. However, she also captures the new trend toward more personal imagery by using a soft color palette instead of incorporating strong, monumental, and highly corporate images.

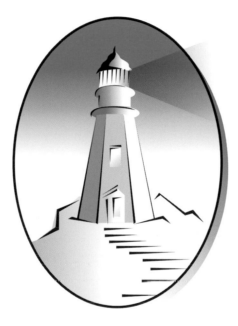

HURON
PHYSICAL REHABILITATION

PROJECT> **Tex Dance Studio Brochure**
DESIGN FIRM> **Ana Couto Design,**
Rio de Janeiro, Brazil
CLIENT> **Tex Dance Studio,**
Rio de Janeiro, Brazil
ART DIRECTOR> **Ana Couto**
DESIGNERS> **Luciana de Faria,**
Roberta Gamboa
PHOTOGRAPHER> **Adelmo Lapa**

The footlights, the flawless, graceful, precise movement of the dancers—that is the outsider's view of dance. This brochure for Tex Dance Studio reaches out to dancers with the true story— endless practice, sweat, calluses, and blisters. But to people who are serious about it, this is the truth of dance. The motion of the images is accentuated but not overpowered by the fonts and the layouts.

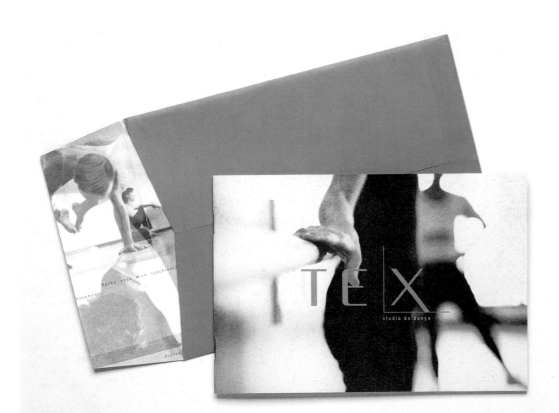

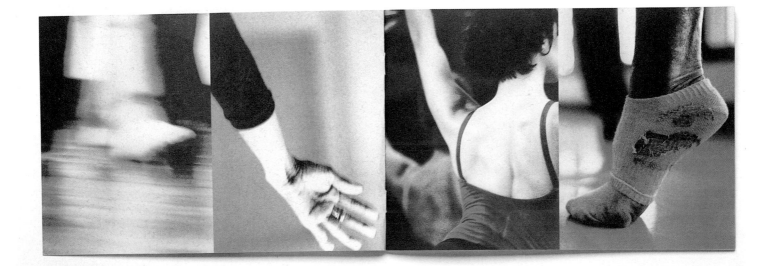

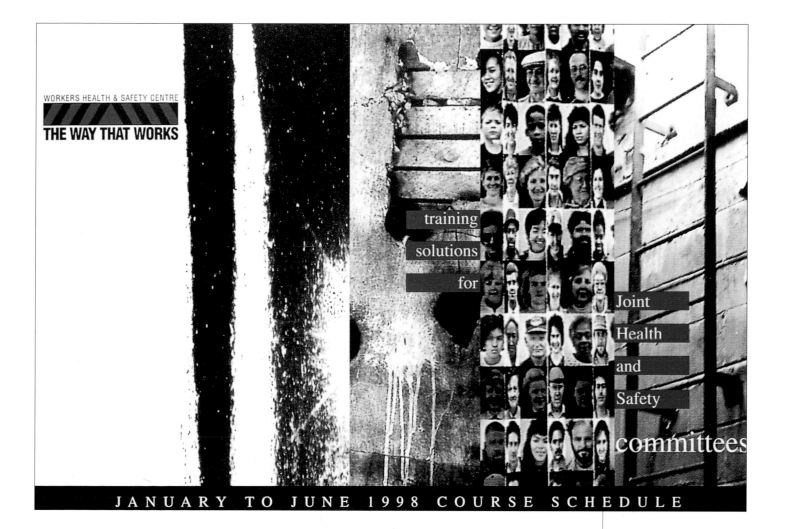

WORKERS HEALTH & SAFETY CENTRE

THE WAY THAT WORKS

training solutions for Joint Health and Safety committees

JANUARY TO JUNE 1998 COURSE SCHEDULE

PROJECT> Training Solutions for Joint
Health and Safety Committee Booklet
DESIGN FIRM> Terrapin Graphics,
Toronto, Ontario, Canada
CLIENT> Workers Health and Safety Centre,
Toronto, Ontario, Canada
ART DIRECTOR/DESIGNER> James Peters
ILLUSTRATOR> James Peters

The layouts in this Workers Health and
Safety booklet do not attempt to bury
the body text, which would allow read-
ers to skim the images and pull quotes.
The presentation is well balanced, so
that all information comes to the fore.

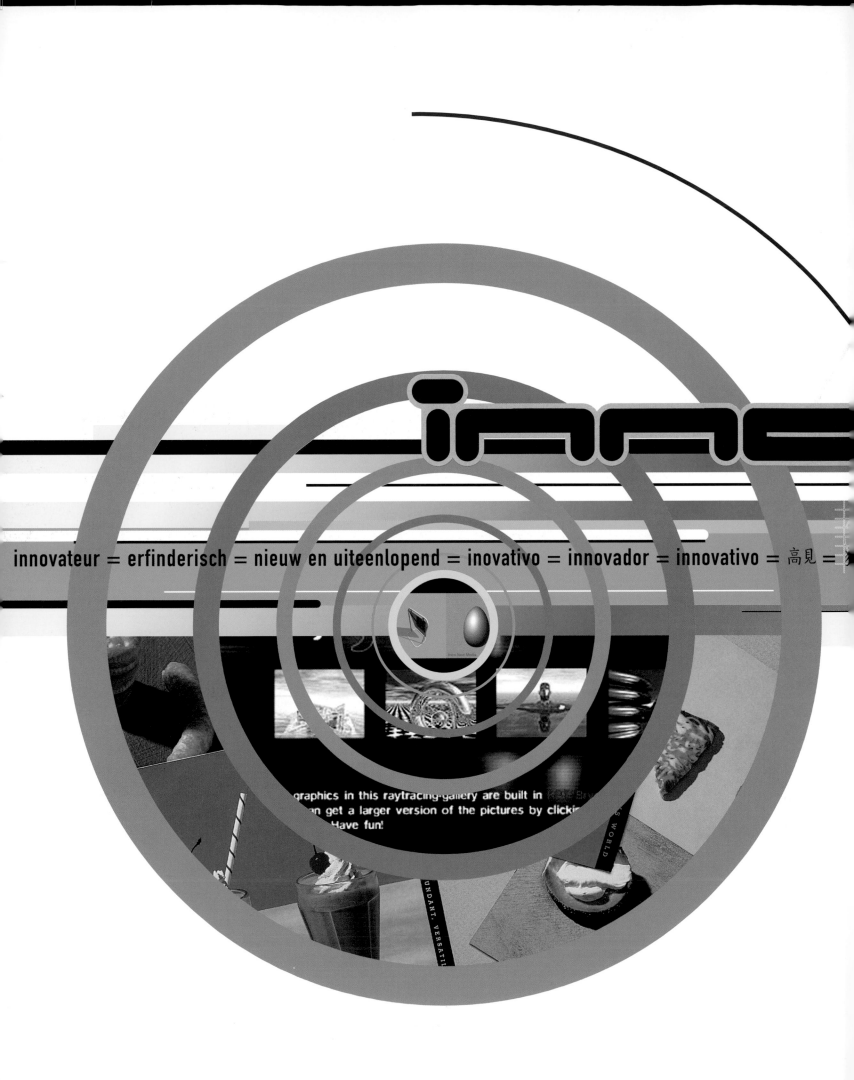

innovateur = erfinderisch = nieuw en uiteenlopend = inovativo = innovador = innovativo = 高見 =

vative

創的的 = **innovative**

A radically new or different approach is often described as innovative. But simply making alterations to an already established form, working within an accepted theme, can occasionally be an even more effective approach to innovation. All design is a matter of arranging (or omitting) the fundamental building blocks: images and text. Innovation involves finding better ways to arrange them. The greatest innovations are the ones that, although they are new and different, appear to be obvious solutions— solutions that explain themselves and do not need to be justified as innovative.

"Our client allowed us to research the market. The client had no preconceived notion on a direction. Once the client studied our research, they decided on a new, innovative direction."

Elizabeth Draht,
Grafik Communications

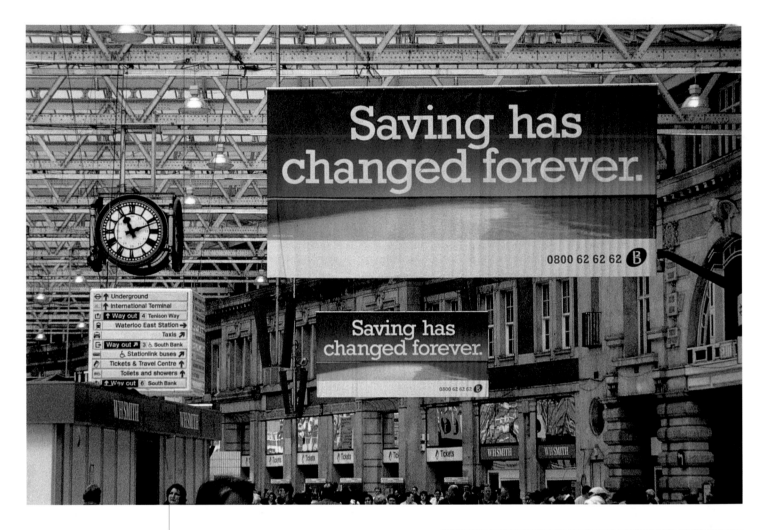

PROJECT> **Barclay Bank Identity**
DESIGN FIRM> **The Partners,**
London, England
CLIENT> **Barclay Bank, London, England**
ART DIRECTORS> **David Stuart, Gillian Thomas**
SENIOR DESIGNER> **Tracy Avison**
DESIGNERS> **Martin Lawless, Andrea Carey, Ian**
Lanksbury, Stuart Grant-Fuidge
PROJECT MANAGER> **Maryanne Murray**

The client wanted an innovative branding that would identify Barclay Bank's latest innovation in personal savings. The Partners played a key role in the development of Barclay's brand values and philosophy: fresh, modern, open, and accountable. In a unique, integrated approach, the communication elements work together to crystallize and simplify this new product concept to its audience, broadcasting a solid but informal rather than corporate message.

PROJECT> **Dairy Promotion Package**
DESIGN FIRM> **Grafik Communications,**
Alexandria, Virginia, USA
CLIENT> **U.S. Dairy Export Council,**
Arlington, Virginia, USA
DESIGNERS> **Johnny Vitorovich,**
Judy Kirpich
PHOTOGRAPHERS> **Peter McArthur,**
David Sharpe

The client had no preconceived ideas of a direction. The designers listened to the client's needs and reviewed the marketing research and budget issues. The result was a new branding program whose images are all familiar, yet whose treatment is anything but. The end product is remarkably readable and manages to infuse with excitement a topic that could have been as interesting as warmed soy cheese.

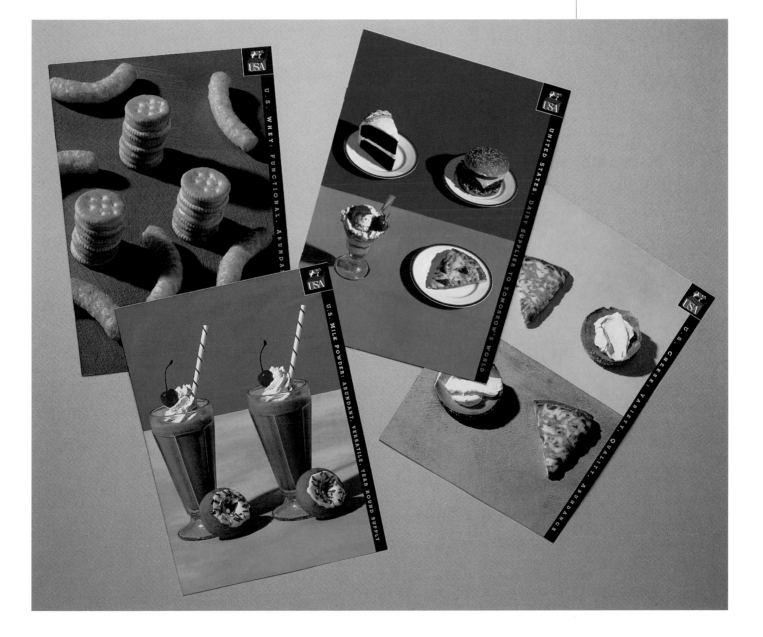

PROJECT> The Graphic Home Web Site
(www.graphic-home.iok.net)
DESIGN FIRM> Dirk Rullkötter AGD
(Advertising + Design),
Kirchlengern, Germany
CLIENT> Marco Rullkötter,
Kirchlengern, Germany
DESIGNER> Dirk Rullkötter

Low-resolution images are a major complaint in Web design. Here, both problems are overcome by using intentionally blurred type and images shot from a video monitor. The images are eerily appropriate for the Web; they have flaws that screen viewers have learned to ignore by watching television day after day until they no longer see the horizontal and vertical lines. Rather than diminishing the images, the effect animates them.

Netscape: Intro

Back Forward Home Reload Images Open Print Find Stop

Location: http://www.introactive.co.uk/

Intro

Intro New Media

Document: Done.

PROJECT> **Intro Web Site**
(www.introactive.co.uk)
DESIGN FIRM/CLIENT> **Intro, London, England**
ART DIRECTOR> **Adrian Shaughnessy**
DESIGNER/ILLUSTRATOR> **Yannis Marcou**
ANIMATOR/PROGRAMMER> **Adelmo Lapa**

A 3-D animation sequence and a brown egg become an innovative splash screen for Intro Design's studio Web site. The skillful rendering of these seemingly simple images entices viewers' curiosity but does not bore them with long download times. The following text screen has stylistic roots in the 1960s that transfer seamlessly to this new medium: big sans-serif type in an off-tone of the background fills the page.

LIBRARY & RESOURCES AREA - EPSOM CAMPUS

THE SURREY INSTITUTE OF ART & DESIGN

inviting

a c

To some extent, every design solution must be accessible. Every visual needs to communicate to its target audience, even if strictly in abstract terms. However, some design solutions go out of their way to welcome viewers and, as opposed to eye-catching designs, which employ high-impact effects to hook viewers, draw them in gently. Where sex, strength, and even humor can turn away certain viewers, accessible designs are geared to appeal a wide crosssection of viewers. Inviting imagery is upbeat and cheerful. Smiling faces, sunny skies, circles of friends, open doors, extended hands, and happy children reach broad audiences when they are portrayed in ways with which viewers can quickly identify.

"Sometimes the client already has a design solution in mind, in which case we may need to work to overcome being shoehorned down one route. Being able to make a good logical case, talk with conviction and passion, and show alternatives in addition to the solution suggested generally works."

David Stuart and Carrie Stokes,
The Partners

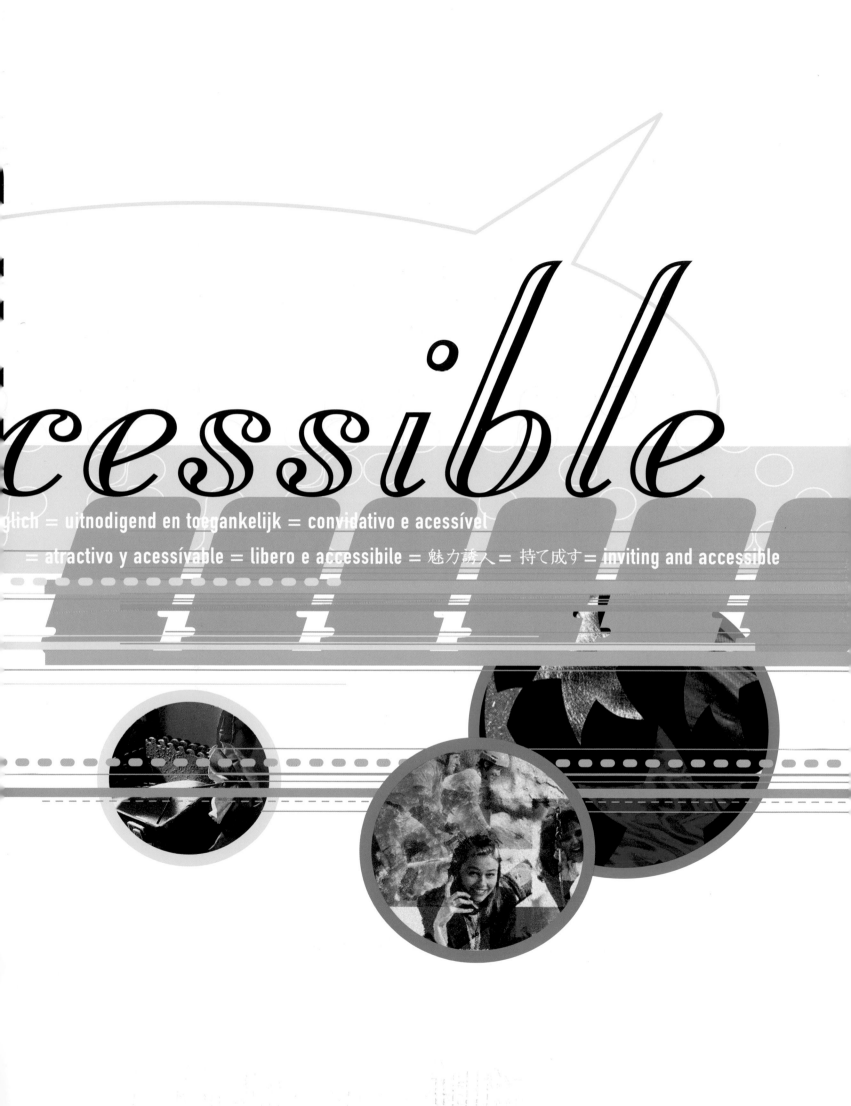

cessible

glich = uitnodigend en toegankelijk = convidativo e acessível

= atractivo y acessívable = libero e accessibile = 魅力誘人 = 持て成す= inviting and accessible

s1tv

SINGAPORE INTERNATIONAL TELEVISION

PROJECT> Singapore International
Television Station Identity
DESIGN FIRM> The Bonsey Design
Partnership, Singapore
CLIENT> Singapore International
Television, Singapore
ART DIRECTOR> Jonathan Bonsey

If you wish to create a masterpiece, then your influences must be master-pieces. To create the corporate identity for Singapore International Television, Bonsey Design brought the five stars of Singapore's national flag to life, drawing on Matisse's *La Danse* (itself a highly inviting and accessible work) for inspiration.

PROJECT> *Away* Poster
DESIGN FIRM> Inkahoots Design,
Brisbane, Queensland, Australia
CLIENT> La Boite Theatre,
Brisbane, Queensland, Australia
ART DIRECTOR/DESIGNER> Jason Grant
ILLUSTRATOR> Donna Kendrigan

This window into a small world entices viewers to let their eyes and imagination wander into the central image on this theater poster. The title type plays a double role as clouds over the diorama.

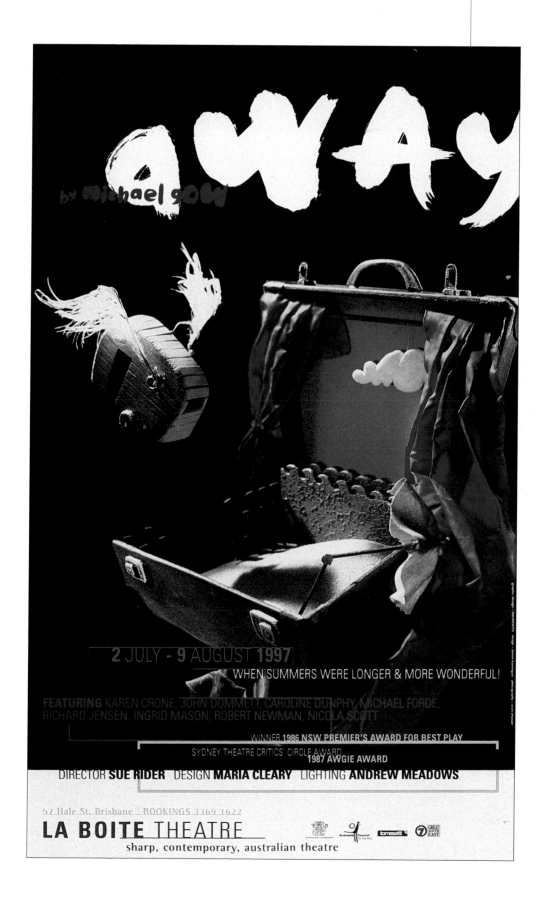

PROJECT> Bell Canada CD Cover
DESIGN FIRM> Yfactor, Inc.,
Brampton, Ontario, Canada
CLIENT> Sequence Productions
and Bell Canada,
Toronto, Ontario, Canada
ART DIRECTOR/DESIGNER> Anya Colussi

This cover for a Bell Canada CD uses diverse faces to appeal to a cross-section of the population. Fewer faces appear, so Anya Colussi wisely concentrated on women and children, who are accessible to both men and women. (However, studies have shown that in designs for children, both girls and boys more readily identify with images of boys than girls.)

PROJECT> *Inside* Newsletter Format Design
DESIGN FIRM> **Neo-Graphic Communications,**
Nanaimo, British Columbia, Canada
CLIENT> **Credit Union Central,**
Vancouver, British Columbia, Canada
ART DIRECTORS> **Valerie Luedke,**
Doree Kustra
DESIGNER/ILLUSTRATOR> **Donna Kendrigan**

Smiling faces, warm tones, and informal, upbeat graphics are the obvious inviting points in this credit-union newsletter, but the selection of an informal typeface, its legible point size, the easy flow of text, and the downplayed charts are of equal importance in this outstanding solution. (Charts can quickly intimidate or simply bore viewers if they are given too much emphasis.)

l i g h t

AIRY

clair et aéré = leicht und locker = licht en luchtig =

jovens e iluminados = alegre y aireado = leggero = 通爽 = フワフワ

(AND)

ada no compromisso, fundam

= light and airy

Design solutions need not be overbearing to get their messages across. To stand out, a visual presentation simply must provide a contrast to its surroundings. As the world becomes increasingly crowded and urban, escapist images—soft, tranquil, and soothing tones—stand out against a background of bold, strong, and even playful images competing for viewers' limited attention. Though it is tempting to limit light-and-airy design to a summer palette, even fall, winter, and spring visuals can work if they are interpreted through softer media such as pastels and watercolors.

"When working on an international project, involve a national [someone from the country in question] on the project or someone who knows the country and language. Have meetings in their country at the start of projects."

David Stuart and Carrie Stokes,
The Partners

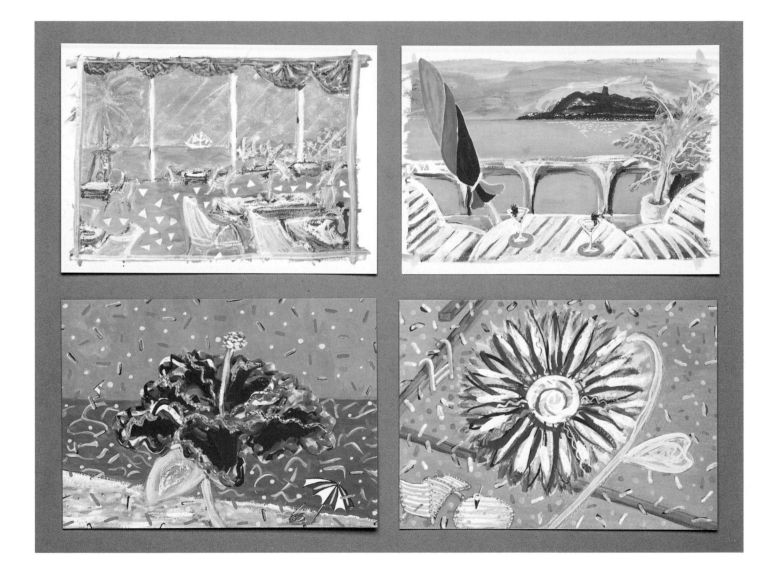

PROJECT> **Shonan Brand Shoreline**
Village Postcards
DESIGN FIRM> **Mihama Creative Associates,**
Yokohama, Japan
CLIENT> **Shonan Brand, Kanagawa, Japan**
ART DIRECTOR> **Kimihiko Yoshimura**
DESIGNERS> **Kazumi Ohtani,**
Kimihiko Yoshimura
ILLUSTRATOR> **Kazumi Ohtani**

One of the most successful recent trends in promotion and publicity is postcards that transcend advertising to become art. To capture the essence of a resort, Mihama Creative Associates created this compelling set of images that offer viewers a visual taste of warm summer days at the beach.

PROJECT> Himawari Festa '94
Poster and Leaflet
DESIGN FIRM> Mihama Creative Associates,
Yokohama, Japan
CLIENT> Yokohama City, Yokohama, Japan
ART DIRECTOR> Kimihiko Yoshimura
DESIGNER> Yuka Mori (Forlin Studio)
ILLUSTRATOR> Kazumi Ohtani

Even classically bold imagery can be used to create a light-and-airy design solution. In this festival poster, the strong image of the sun is softened by a tranquil background scene.

PROJECT> Asia Pathways Corporate Identity
DESIGN FIRM> The Bonsey Design
Partnership, Singapore
CLIENT> API Holding Pte., Ltd., Singapore
DESIGNER> Jonathan Bonsey
WEB DESIGNER> Damien Thomasz

As so many corporate identities simply look corporate, nontraditional images, such as these flower seeds blowing in a light breeze, stand out. A light and delicate touch can add elegance to an otherwise strong logo, as it does here.

asia pathways

PROJECT> **Redesign Web Site**
(www.aisl.co.uk/redesign/homepage.html)
DESIGN FIRM/CLIENT> **Redesign,**
Edinburgh, Scotland
ART DIRECTOR/DESIGNER> **Regina Fernandes**
ILLUSTRATOR> **Regina Fernandes**

Though butterflies seem an obviously light-and-airy motif, it is Regina Fernandes's execution of this Web site's design that lends it an ethereal quality. The string of butterflies rising off the page, as well as the string tangled whimsically around the navigation buttons, is refreshingly alive and organic.

PROJECT> Hong Kong Committee
on Children's Rights Web Site
(www.childrenrights.org.hk)
DESIGN FIRM> Clic Limited,
Quarry Bay, Hong Kong, China
CLIENT> Hong Kong Committee
on Children's Rights,
Hong Kong, China
ART DIRECTOR> Nicholas Tsui
DESIGNER> Barbara Chan

This Web site, created by Clic Limited
for the Hong Kong Committee on
Children's Rights, uses light and bright
colors, a whimsical circular table of
contents, and plenty of white space to
help the various elements stand out.

Sempre baseada no compromisso, fundamental, de transformar energia em conforto

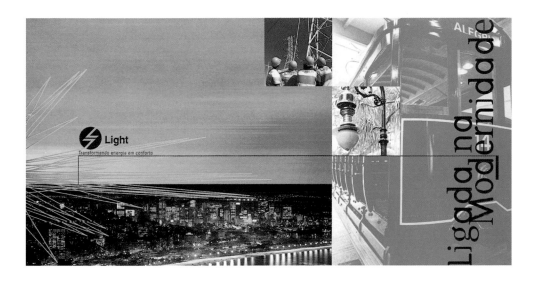

PROJECT> **Light Electric Company Brochure**
DESIGN FIRM> **Ana Couto Design,**
Rio de Janeiro, Brazil
CLIENT> **Light Electric Company,**
Rio de Janeiro, Brazil
ART DIRECTOR> **Ana Couto**
DESIGNERS> **Ana Couto, Natascha Brasil,**
Cristiana Nogueira
ILLUSTRATOR> **Natascha Brasil**

Silver ink laid over images and under text creates a distinctly layered appearance. In effect, it allows three levels to exist on the page, opening up visual breathing space in each. Intermittent spreads bisected by a single line of text and illuminated by soft, multicolored lights contribute to the feeling.

Pleasantly humorous, a playful design solution is funny. Unlike a presentation that relies on satire, irony, or ridicule to create humor, a playful image is filled with glee and jauntiness. It is a lighthearted visual frolic that uplifts the viewer's spirits with its sportive sense of upbeat, positive fun and innocence. A classic example of playful imagery is Coppertone sun lotion's branding featuring a puppy revealing a little girl's sunburn line by tugging at her bathing suit. Playful images can be cartoonish, bright, subtle, high-tech, or down-to-earth. The key element is the fun.

"I think words nowadays have the same meaning everywhere."

Regina Fernandes,
Redesign

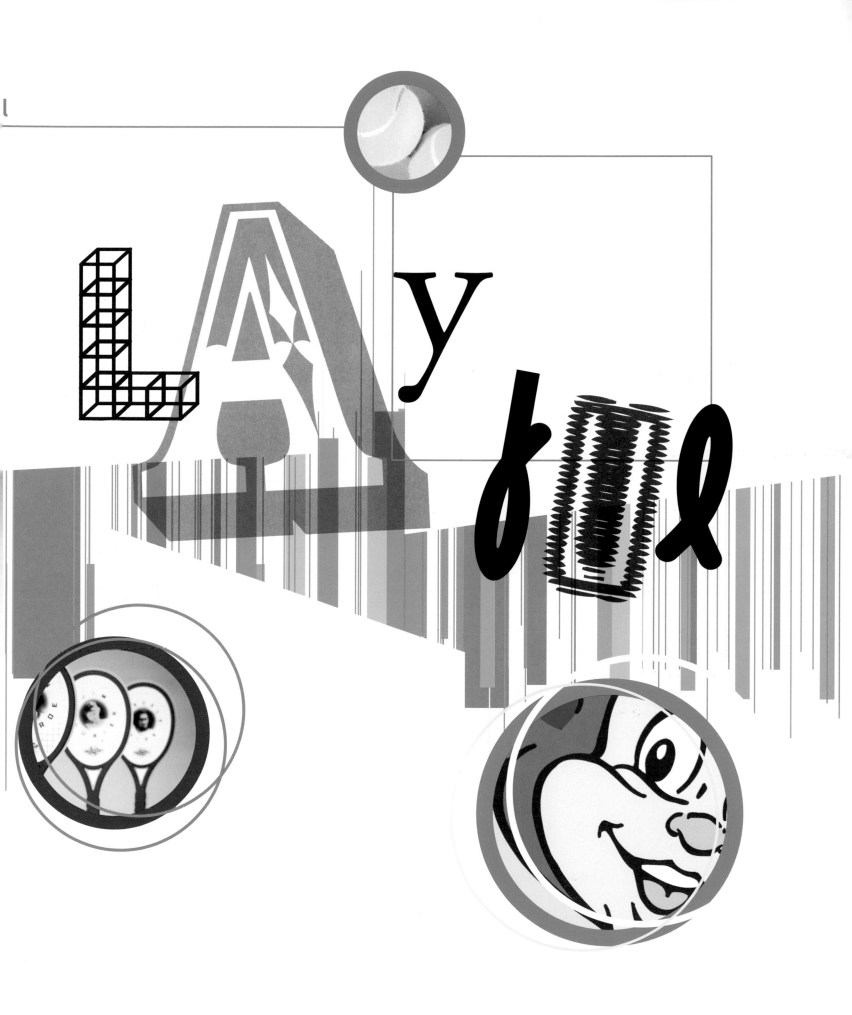

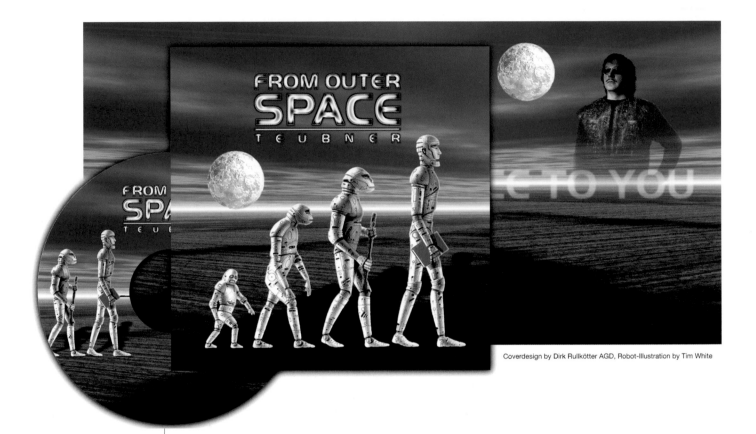

Coverdesign by Dirk Rullkötter AGD, Robot-Illustration by Tim White

PROJECT> *From Outer Space* CD Cover,
Booklet, and Label
DESIGN FIRM> Dirk Rullkötter AGD
(Advertising + Design),
Kirchlengern, Germany
CLIENT> Teubner Production,
Hanover, Germany
ART DIRECTOR/DESIGNER> Dirk Rullkötter
ILLUSTRATOR> Tim White

The key to visual humor is to take the familiar and portray it in a new light. Here the classic evolution-of-man diagram is parodied in robotics. As this is a music CD, the image has other humor points as well, such as poking subtle fun at the Beatles' *Abbey Road* album cover, on which the band is pictured crossing the street.

PROJECT> **Hand Job Logo**
DESIGN FIRM:> **Amoeba Corporation,**
Toronto, Ontario, Canada
CLIENT> **Maryland Screen Printing,**
Baltimore, Maryland, USA
ART DIRECTOR/DESIGNER> **Michael Kelar**
ILLUSTRATOR> **Mikey Richardson**

While this clothing line's risqué name might qualify it as young design (treading the edge of obscenity can grab the attention of masses of youthful viewers), the logo itself is playful. In cartoonish personification, this hand comes to vibrant life.

PROJECT> **Nike Cup Identity**
DESIGN FIRM> **Mires Design, Inc.,**
San Diego, California, USA
CLIENT> **Nike, Inc., Beaverton, Oregon, USA**
ART DIRECTOR> **John Ball**
DESIGNERS> **John Ball,**
Deborah Hom, Miguel Perez

The Nike Cup is an entertainment-driven tennis tourney that features spectator-friendly rules and a comic emcee. The designers created a logo reflecting this subversive yet playful attitude, then surrounded it in presentation materials with the people and elements that make tennis exciting. The logo itself is playful: the twisting net and title type are obvious, but the underlying sweep that continues the momentum drives its full impact.

PROJECT> **Stolichnaya Vodka Martini Web Site**
(**www.winespectator.com/Wine/Spectator/Martini/**)
DESIGN FIRM> **M. Shanken Communications,Inc.,**
In-house Art Department,
New York, New York, USA
CLIENT> **Stolichnaya Vodka,**
St. Petersburg, Russia
CREATIVE DIRECTOR/DESIGNER> **Ellen Diamant**
PHOTOGRAPHER> **Courtney Grant Wilson**
STYLIST> **Susan Dettavenon**

Stolichnaya Vodka wanted the look of this advertorial and accompanying Web site to be fun yet sophisticated enough to reach the readers of *Wine Spectator* magazine. Ellen Diamant created a virtual lounge party using a festive color palette, bright cocktail spot images, and open or overlapped lines rather than standard clickboxes. The enticing headers and opening images on each page draw viewers deeper into the text.

PROJECT> **Who Cares? Wine Labels**
DESIGN FIRM> **Barbara Harkness**
Design Pty., Ltd.,
Adelaide, South Australia, Australia
CLIENT> **Geoff Merrill Wines,**
Reynella, South Australia, Australia
DESIGNER/ILLUSTRATOR> **Barbara Harkness**
PHOTOGRAPHER> **Clayton Glen**

The name Who Cares? is inspired branding for a table wine. It implies leisure and escape from life's demands. This lighthearted and humorous design is a perfect visual counterpart to the name. Meant to satirize wine selection based on label rather than quality, it stands out against traditional labels. Of course, a playful design risks diminishing a product's appearance, but if handled skillfully, as here, the effect can be positive.

PROJECT> **Efteling Corporate Identity**
and Efteling Hotel Identity
DESIGN FIRM> **Designstudio Kees Uittenhout BNO,**
Wijk en Aalburg, Netherlands
CLIENT> **Efteling, Kaatsheuvel, Netherlands**
ART DIRECTOR> **Kees Uittenhout**
DESIGNER> **Brigitte Jongstra**

Sometimes playful need not be subtle. A historic image of celebration, the jester is a daring image for a logo—unless the company is in the leisure business. Efteling is. In Europe, where royal courts always had jesters, this image is familiar and the message clear. The logo's execution is lively and communicative; the jester creates magic with the sweep of his hand. The festive color palette carries the mood.

retro = teruggaand = retrogrado = 懷舊 = 遡及 = retro

Touted as a new trend, retro imagery and design has been around as long as design has had a past. However, the term *retro* has taken on more specific connotations lately, referring primarily to stylized interpretations of 1950s lounge culture as well as 1920s and 1930s advertising. (The graphic styles of the 1960s and 1970s have also regained popularity and, though they are more accurately labeled *psychedelia* and *disco* respectively, they are appearing with great frequency under the retro umbrella.) Cocktail-party images include martinis, cocktail shakers, hi-fi stereos, men in double-breasted suits, women in cocktail dresses, tikis and tiki torches, amorphous or geometric space-age shapes, and even coffee and cigarettes.

"Design is very subjective even for designers."

Miguel Solak,
Corh Consultores

PROJECT> Graphic Design People
Seminar Poster
DESIGN FIRM> BAC Propaganda/
Rafa Ferreira Design,
Campinas, SP, Brazil
CLIENT> People Computação ADG,Campinas,
Campinas, SP, Brazil
ART DIRECTOR/DESIGNER> Rafael Peixoto Ferreira
PHOTOGRAPHER> Mike Salisbury
(Mike Salisbury Communications)

Using pop colors, fonts, and a central
image reminiscent of a Roy Lichtenstein
portrait, Rafael Peixoto Ferreira sets
a retro tone in this poster for a seminar
and workshop with pop design icon
Mike Salisbury.

PROJECT> Ontario Speaks Out Promotion
DESIGN FIRM> Terrapin Graphics,
Toronto, Ontario, Canada
CLIENT> Ontario Federation of Labour,
Toronto, Ontario, Canada
ART DIRECTOR/DESIGNER> James Peters
ILLUSTRATOR> James Peters

These bold black-and-white posterized contrasts have their roots in 1960s post-pop art. The abstract Judy Garland image strengthens the retro feel, while the contemporary type treatment pulls the overall design back to modern day.

PROJECT> **Zing Self-Promotion Brochure**

DESIGN FIRM/CLIENT> **Amoeba Corporation, Toronto, Ontario, Canada**

ART DIRECTORS> **Michael Kelar, Mikey Richardson**

DESIGNER> **Michael Kelar**

ILLUSTRATORS> **Mikey Richardson, Steve McArdle**

PHOTOGRAPHER> **Nation Wong**

The imagery and text of this self-promotional brochure read like a combination of 1950s educational movies and a Charles Atlas "Tired of getting sand kicked in your face?" ad. Even the Zing logo draws elements from the atomic symbol—the banner of the future in the 1950s. Complex 3-D images and a variety of design and illustration styles are also incorporated. The result? A polished and effective capabilities brochure.

PROJECT> Keep It Weird Poster
DESIGN FIRM> Amoeba Corporation,
Toronto, Ontario, Canada
CLIENT> Youth Television (YTV),
Toronto, Ontario, Canada
ART DIRECTOR/DESIGNER> Michael Kelar
3-D ILLUSTRATOR> Steve McArdle

If designers in the 1960s had access to computers with 3-D imaging and animation capabilities, the decade might have looked like this poster for Canada's YTV, a television station that targets younger viewers. The fly is a recurring image in YTV promotions; however, the television, the frenetic type, the abstract planets, and the airwaves are unique.

PROJECT> Creation Records, Mute Records,
Just Deakin Postcard Campaign
DESIGN FIRM> Intro, London, England
CLIENTS> Creation Records,
Mute Records, Just Deakin, Intro,
London, England
ART DIRECTOR/DESIGNER> Adrian Shaughnessy

Perhaps the popularity of swank, retro styling is because the sleek geometric curves and bright colors of the 1950s furniture and the polished chrome of cocktail shakers are perfect subjects for re-creation as computer-generated 3-D images. But these designs go beyond that. Diner food is another icon of the 1950s and 1960s, as were the Black Panthers.

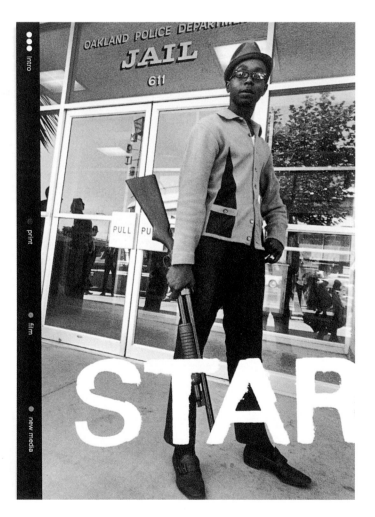

Netscape: Shockwave

Back | Forward | Home | Reload | Images | Open | Print | Find | Stop

Location: http://192.150.139.115/qtacentry3.html

Document: Done.

PROJECT> Queensland Tertiary
Admission Centre Web Site
(www.qtac.edu.au)
DESIGN FIRM> Inkahoots Design,
Brisbane, Queensland, Australia
CLIENT> Queensland Tertiary Admission Centre,
Brisbane, Queensland, Australia
ART DIRECTOR/DESIGNER> Steve Alexander

Though not as easily recognizable as some other retro styles, the graphics on this site also harken back to 1950s illustrative styles. The looks of wonder and joy are highly appropriate for an on-line college admissions center.

Although the term *rich* is often associated with wealth, it can also indicate sumptuousness or elaborate abundance, like the cuisine offered in a five-star restaurant. Rich can also describe a depth of color, such as rich purple, implying the use of strong, vivid tones. The classic color palette for conveying a sense of opulence draws from a wealth of aristocratic sources; colors such as burgundy, gold, royal purple, royal blue, and ivory have for centuries been associated with the ruling classes. Icons of conspicuous wealth, from sports cars, gold, racehorses, yachts, and mansions to less ostentatious items like top hats, bow ties, champagne, and caviar, are all commonly used elements of rich visual presentations, even if their use is subtle or subliminal.

"In my experience, clients don't respond to "show and tell" ("Show us what you mean by clean"), as they're often a little intimidated by the creative team and fear appearing foolish or naive. The stimulus material generally takes clients beyond the limit of their initial thinking; we are seen to be making their life easier and place ourselves firmly in the driving seat."

David Stuart and Carrie Stokes,
The Partners

prospère = reich = rijk = rico = suntuoso

= ricco = 豊富 = 豊か = rich

PROJECT> Qualcomm Q Lady Package
DESIGN FIRM> Mires Design, Inc.,
San Diego, California, USA
CLIENT> Qualcomm,
San Diego, California, USA
ART DIRECTOR> José A. Serrano
DESIGNERS> José A. Serrano,
Deborah Hom

In developing a packaging program for
Qualcomm's new line of high-end
phones, the designers created a brand
that focuses on their distinguishing
features. This is an excellent example
of a rich design solution working with
modern colors and visual ingredients.
The model is flawless, the elements are
balanced and uncrowded, and the
hues are highly saturated. The final
product is presented in the way a
diamond necklace might be.

PROJECT> **Ideal Graphics, Inc.,**
Promotional Campaign
DESIGN FIRM> **Hal Apple Design,**
Manhattan Beach, California, USA
CLIENT> **Ideal Graphics, Inc.,**
Gardena, California, USA
ART DIRECTOR> **Hal Apple**
DESIGNER> **Andrea del Guercio**
PHOTOGRAPHERS> **Tracy Lamorica,**
Jesse Chen, Juni Banico,
Jason Ware, Ivan Lopez

As Hal Apple says, this is the world's smallest brochure (about 3 inches tall). But the client directed the designers to do whatever they wanted. The team chose a small but very elegant solution. Good things, it seems, really can come in small packages.

LIBRARY & RESOURCES AREA - EPSOM CAMPUS
THE SURREY INSTITUTE OF ART & DESIGN

seriou

sérieux = serioes = serieus = sério

us

= grave = 嚴謹 = 重大視 = serious

Earnest and sincere, a serious design solution portrays the depth and weight of its subject. The viewer cannot mistake the presentation as a mere trifle or piece of satire because the images and text treatment are somber and sedate in their demeanor. Direct, to the point, businesslike, professional—serious designs communicate the intended message without humor, without embellishment, and with a maximum of efficiency. Serious, however, should never be misconstrued as boring. Though the chief building blocks here are substance and message rather than design concept and tone, the result can range from refined and feminine to stark and bold.

"Ultimately, good design is sourced at a place common to all of us. It comes down to visually conveying an idea that anyone can recognize, and yet has the interest of being revealed in a new way. A basic human truth is that our desire for comfort is equally matched by a need for intrigue. When both are delivered equally, you have created a pattern between old and new, order and chaos, comfort and risk. Perhaps small, but nonetheless, an evolutionary step."

Maggie Macnab,
Macnab Design Visual Communications

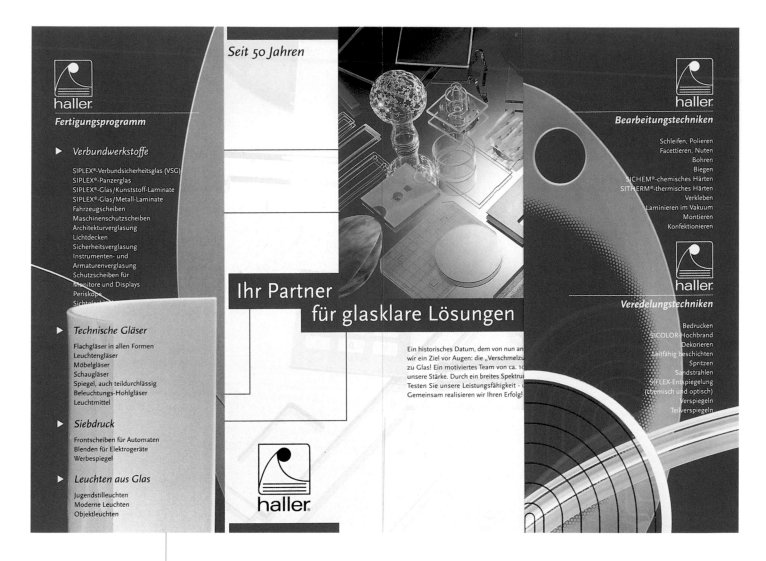

PROJECT> **Glaswerke Haller**
GmbH Image Folder
DESIGN FIRM> **Dirk Rullkötter AGD**
(Advertising + Design).
Kirchlengern. Germany
CLIENT> **Glaswerke Haller GmbH.**
Kirchlengern. Germany
ART DIRECTOR/DESIGNER> **Dirk Rullkötter**

In this presentation folder for an industrial glassmaker, Dirk Rullkötter captures the art and precision craft of the Haller glassworks through the artful juxtaposition of varied products. The beauty of the pictures is offset by extensive capabilities summaries, resulting in a highly effective tool for delivering information.

PROJECT> **No Longer Silent**
Presentation Folder
DESIGN FIRM> **Terrapin Graphics,**
Toronto, Ontario, Canada
CLIENT> **Ontario Federation of Labour,**
Toronto, Ontario, Canada
ART DIRECTOR/DESIGNER> **James Peters**
ILLUSTRATOR> **James Peters**

As the saying goes, "The eyes are the windows to the soul." Here, a pair of photographs of eyes conveys fear and anger, strong emotions that are appropriate for the subject of this presentation folder: domestic violence. The belt, closed on the cover and open inside, reinforces the message.

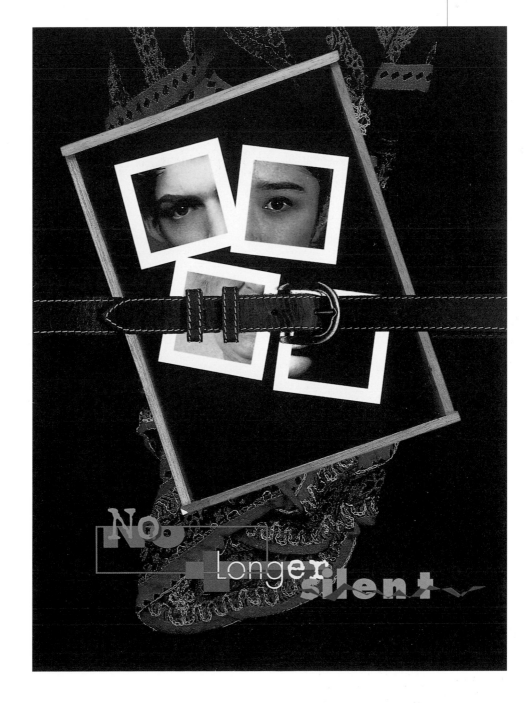

PROJECT> **Vugts Consultancy Housestyle**
DESIGN FIRM> **Designstudio Kees Uittenhout BMO.**
Wijk en Aalburg, Netherlands
CLIENT> **Vugts Consultancy,**
Waaluijk, Netherlands
ART DIRECTOR> **Kees Uittenhout**
DESIGNER> **Frank Hermens**

This logo, created by Designstudio Kees Uittenhout BMO, demonstrates that creative solutions are possible without resorting to humor, playfulness, or other easy devices for differentiation. A simple reflection of an offset letter gives monolithic dimension and depth while maintaining professionalism.

PROJECT> Lland Graphics Web Site
(www.lland.demon.co.uk)
DESIGN FIRM/CLIENT> Lland Graphics,
Glasgow, Scotland
ART DIRECTOR> Linda Hirshall
DESIGNER> Michael James
PHOTOGRAPHER>James Lland
ILLUSTRATOR>Samuel Alexander
WEB DESIGNER> James Lland

In efforts to be user friendly, many design solutions are friendly to the point that they lose track of the user. Lland Graphics Web site reveals an important quality that its designers have clearly grasped—the ability to design with restraint. Clients who visit the site are treated to fast, highly legible information that is packaged elegantly.

DANIEL B. STEPHENS & ASSOCIATES. INC.

ENVIRONMENTAL SCIENTISTS AND ENGINEERS

PROJECT> **Daniel B. Stephens and**
Associates Brochure
DESIGN FIRM> **Macnab Design**
Visual Communications.
Albuquerque, New Mexico, USA
CLIENT> **Daniel B. Stephens and Associates.**
Albuquerque, New Mexico, USA
ART DIRECTOR/DESIGNER> **Maggie Macnab**
PHOTOGRAPHER> **Stock**

Straightforward yet unpretentious,
this brochure created by Macnab
Design Visual Communications takes a
serious approach without appearing too
visually dense, overbearing, or static.

PROJECT> **Connectool Web Site**
(www.connectool.com)
DESIGN FIRM.> **Dirk Rullkötter AGD**
(Advertising + Design),
Kirchlengern, Germany
CLIENT> **Connectool GmbH,**
Detmold, Germany
ART DIRECTOR/DESIGNER> **Dirk Rullkötter**

There is no smile on the welcome page
of this Web site. Instead, the opening
image is a person focusing intently,
making a detailed measurement.
Subsequent pages continue this sense
of hard work producing precise results.

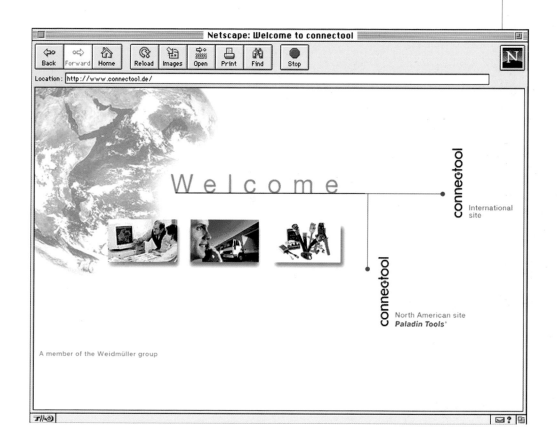

Sex. Is this what everything in design comes down to? Does every design have to breathe sex to get noticed? No. Alluring imagery is not the answer to everything. However, when used properly, it can be very effective. A sexy image is exciting, enticing, and provocative. It exudes glamour and sex appeal, just like a classic European sports car. A luscious red apple, a sensuous color palette, a luxurious piece of satin, a lush green valley can be as sexy as a statuesque woman wearing a diaphanous gown. Unlike a risqué or suggestive visual, a sexy design solution need not imply unnecessary sexuality to convey its message. It can range from subtle to blatant at the designer's discretion—with emphasis on discretion.

"I always try to tie in design concepts with something tangible that clients can grasp. When words like ethereal, avant garde, and conservative, but with an edge fail to get a client's response, I'll use metaphors to help them visualize. For example, I've said, "Should this animation give the feeling of screaming down a roller coaster at 200 miles per hour or a leisurely stroll down the boardwalk?"

Russ Volckmann,
Volksmedia

sexy = sensual = 性感 = 官能的

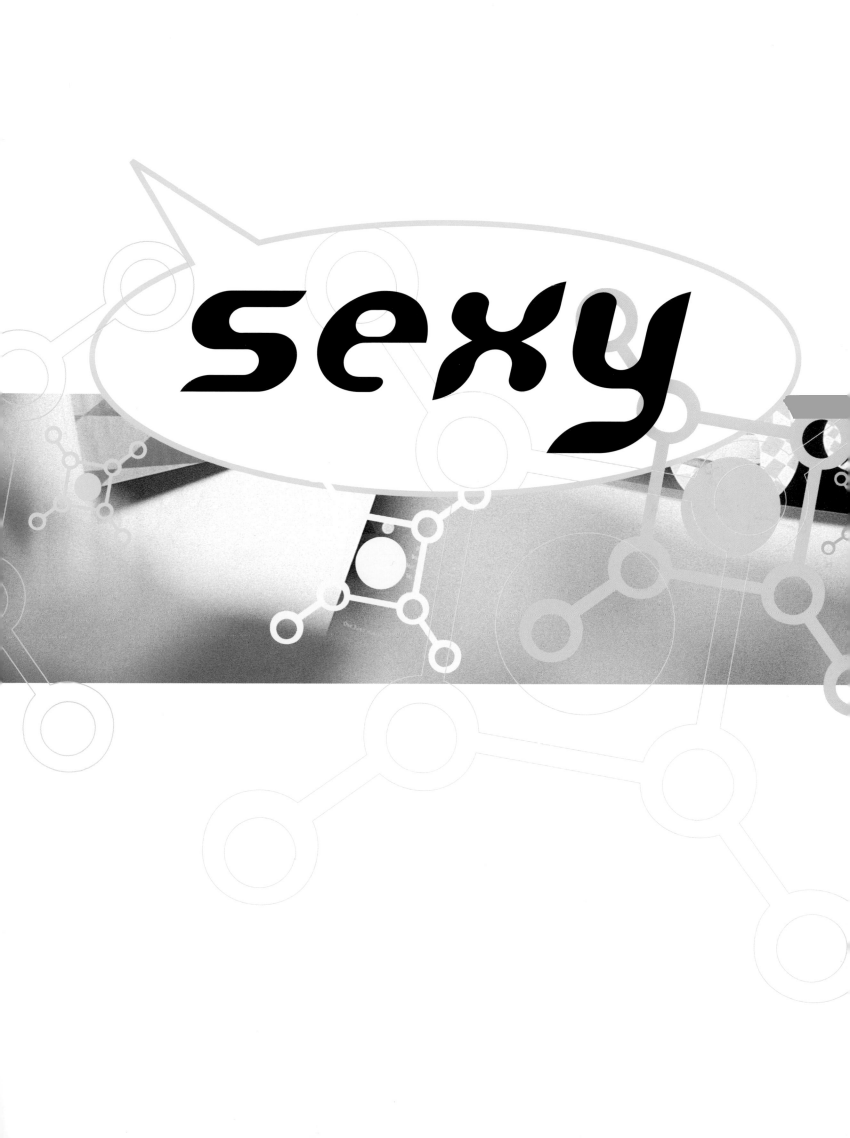

PROJECT> Larry Hansel Look Book
DESIGN FIRM> Hal Apple Design,
Manhattan Beach, California, USA
CLIENT> Rampage,
Los Angeles, California, USA
ART DIRECTOR> Hal Apple
DESIGNERS> Andrea del Guercio,
Alan Otto
PHOTOGRAPHER> Sean Bolger

The designers of this piece wanted it to be rich, sexy, and hip. The book achieves all three qualities. The colors are sexy and rich; the model is sexy and hip; the overlay of text on picture adds to the sensuality of the design. Often the implication of sex is sexier (and safer) than direct sexual imagery. The mind, our strongest sexual organ, is most stimulated by promise and possibility.

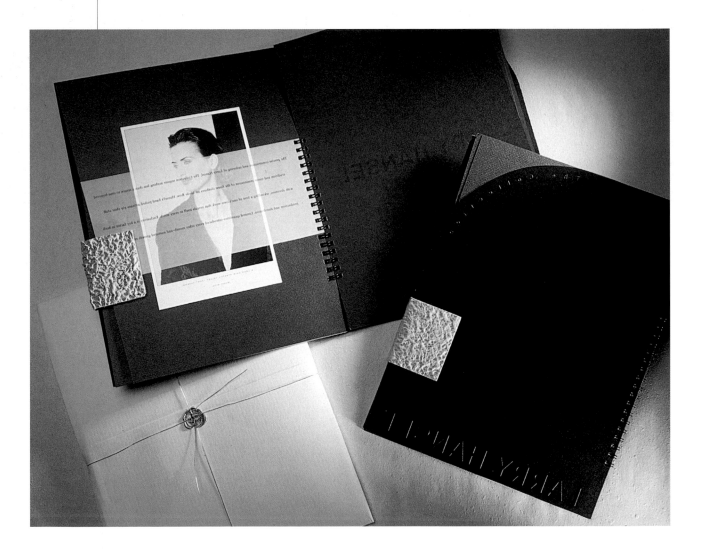

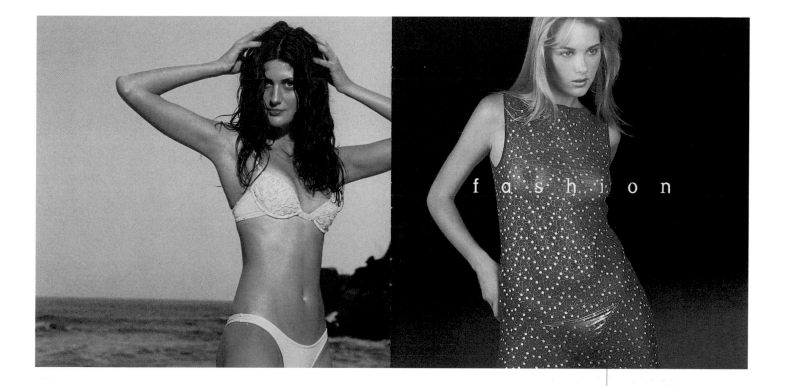

fashion

PROJECT> Rygy Spring/Summer
Collection '98 Catalog
DESIGN FIRM> Ana Couto Design,
Rio de Janeiro, Brazil
CLIENT> Rygy, Rio de Janeiro, Brazil
ART DIRECTOR> Ana Couto
DESIGNERS> Ana Couto, Natascha Brasil
PHOTOGRAPHER> Aderi Costa

Among designers' greatest challenges is knowing when to step back and let the work speak for itself, to keep the design invisible. In this bathing-suit catalog, the images are particularly eloquent—and there is little danger of losing any viewer's attention. Boxes, captions, and other extraneous touches would have detracted from the overall impact.

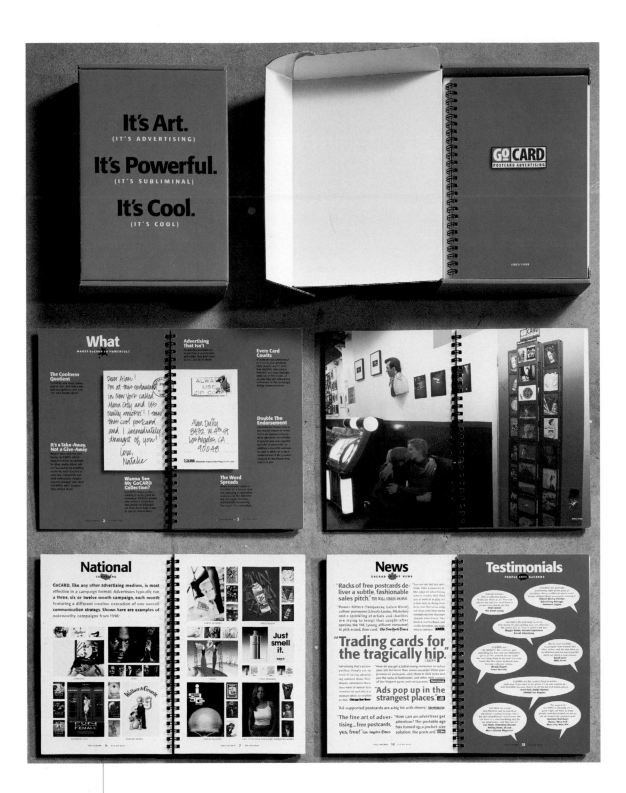

PROJECT> GoCard Promotional Box
DESIGN FIRM> Mires Design, Inc.,
San Diego, California, USA
CLIENT> GoCard, New York, USA
ART DIRECTOR> John Ball
DESIGNERS> John Ball,
Eric Freedman, Sale Spitzley

GoCards are advertising postcards distributed in hip restaurants and stores. With a client directive to create a sexy presentation, the design team created a promotional box containing an informational brochure and samples of the postcards. The box was sent to media buyers and advertising agencies. Clearly, this piece speaks for itself.

PROJECT> Skechers International Catalog
DESIGN FIRM> **Hal Apple Design,**
Manhattan Beach, California, USA
CLIENT> **Skechers,**
Manhattan Beach, California, USA
ART DIRECTORS> **Andrea del Guercio,**
Lisa Joss
PHOTOGRAPHERS> **Willie MacDonald,**
Jason Wane

The client said, "Do whatever you want," so the design team honed their sights on creating a hip and sexy image for this line of footwear geared for a young, body-conscious, appeal-savvy audience. This is clearly achieved using provocative (but not blatant) poses. The models are young, beautiful, and enticing to viewers. The layout even creates a subtle peephole effect.

sportif = sportlich = sportief = esportivo = sportivo = 運動感 = スポーティー = sporty

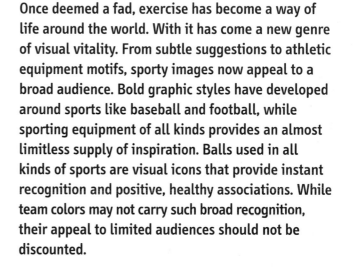

Once deemed a fad, exercise has become a way of life around the world. With it has come a new genre of visual vitality. From subtle suggestions to athletic equipment motifs, sporty images now appeal to a broad audience. Bold graphic styles have developed around sports like baseball and football, while sporting equipment of all kinds provides an almost limitless supply of inspiration. Balls used in all kinds of sports are visual icons that provide instant recognition and positive, healthy associations. While team colors may not carry such broad recognition, their appeal to limited audiences should not be discounted.

"I try to bring some reference works to the client. Sometimes, you need to do a huge presentation and teach the client about the style you use, about the cultural and sub-cultural influences, and about the historical movements."

Rafael Peixoto Ferreira,
Rafa Ferreira Design

PROJECT> **Food Services of America**
Our Winning Team Conference
Campaign Materials
DESIGN FIRM> **Hornall Anderson**
Design Works, Inc.,
Seattle, Washington, USA
CLIENT> **Food Services of America,**
Seattle, Washington, USA
ART DIRECTOR> **Jack Anderson**
DESIGNERS> **Jack Anderson, Cliff Chung,**
David Bates, Mary Hermes
LETTERER> **George Tanagi**

For this Food Services of America marketing conference, the Hornall Anderson design team created a campaign geared toward fostering sandlot enthusiasm and home-team spirit. The baseball theme was a natural for this campaign and was carried so far as to use fresh interpretations of fonts and layout styles classically associated with professional baseball.

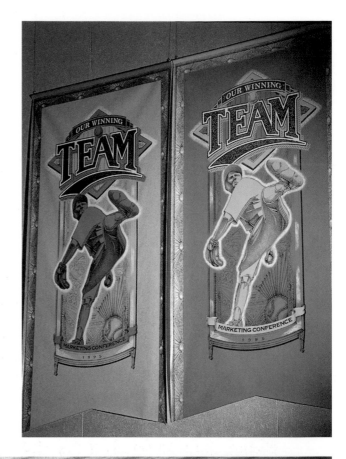

PROJECT> **Agenda 96 Rosário Folder**
DESIGN FIRM> **Corh Consultores,**
Madrid, Spain
CLIENT> **Colégio Nossa**
Senhora do Rosário,
Curtiba, PR, Brazil
ART DIRECTOR/DESIGNER> **Miguel Solak**
ILLUSTRATOR> **Miguel Solak**

In its most abstract form, sporty design brings elements of strong motion. The numbers on the cover for the 1996 agenda of the Colégio Senhora do Rosário could easily be trailing lines behind an illustration of a speeding car or an Olympic freestyle skier. The high contrast of the foreground and background colors emphasizes the motion, ensuring that the cover commands attention.

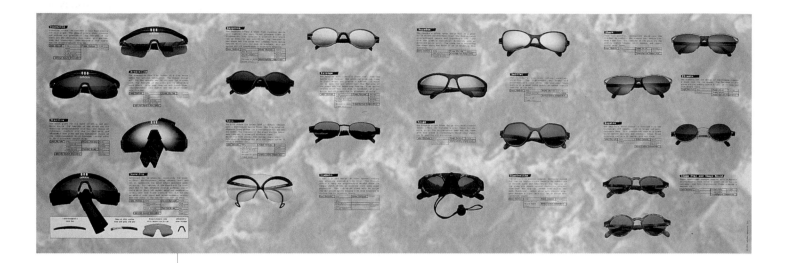

PROJECT> **Adidas Brochure**
DESIGN FIRM> **Hornall Anderson**
Design Works, Inc.,
Seattle, Washington, USA
CLIENT> **Adidas, Kent, Washington, USA**
ART DIRECTOR> **John Hornall**
DESIGNERS> **John Hornall, Viola Lehr**
PHOTOGRAPHER> **Darrell Peterson**

Global urbanization has changed the face of play for today's youth. Playing fields have been replaced by pavement and back lots have become back alleys. These new, tougher conditions make an ideal backdrop for Adidas safety equipment and sports glasses.

PROJECT> Vera Cruz International
Squash Cup Poster
DESIGN FIRM> BAC Propaganda/
Rafa Ferreira Design,
Campinas, SP, Brazil
CLIENT> Xandò Eventos, Campinas, SP, Brazil
ART DIRECTOR/DESIGNER> Rafael Peixoto Ferreira
ILLUSTRATOR> Rafael Peixoto Ferreira

When the design is for a sports event, viewers will readily comprehend abstract images, giving the designer even more freedom. In this poster, which is bursting with motion and depth, a squash ball is rendered step by step from a three-dimensional grid.

PROJECT> **MobilOne Pte., Ltd.,**
Naming, Logo, and Identity Guidelines
DESIGN FIRM> **The Bonsey Design**
Partnership, Singapore
CLIENT> **MobilOne Pte., Ltd., Singapore**
ART DIRECTOR> **Jonathan Bonsey**
DESIGNERS> **Marcel Heijnen,**
Damien Thomasz

To compete with Singapore's established mobile-telecommunications provider, MobileOne needed a distinctive identity. As Bonsey explains, the identity had to "become a badge that stood for the next generation of mobile communications." The new logo's strength comes from ultrabold type and contrasting colors. The identity guidelines sheet shows how to assist a company in maintaining visual cohesiveness by detailing style variations on the logo's treatment.

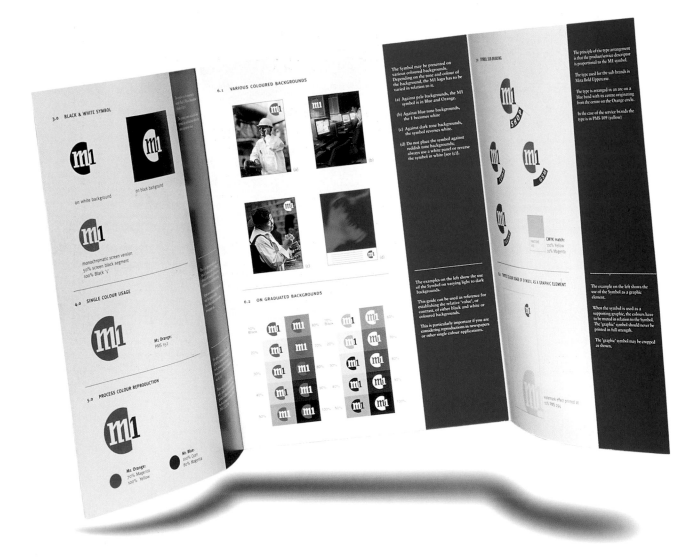

PROJECT> **American Society of Training and Development Web Site (www.astd.org)**

DESIGN FIRM> **e-media-c, Alexandria, Virginia, USA**

CLIENT> **American Society of Training and Development, Alexandria, Virginia, USA**

ART DIRECTOR/DESIGNER> **Eric Goetz**

A strong visual presentation only works if it is well grounded in design fundamentals. As Eric Goetz says, "The success of a Web site is grounded in a look and feel that facilitates access to information. Your site might look great, but if a user can't get where he wants to go fast, that user is gone—most likely never to return." An easy-to-follow flow of information, and the logical structure underlying the design emphasize its strength.

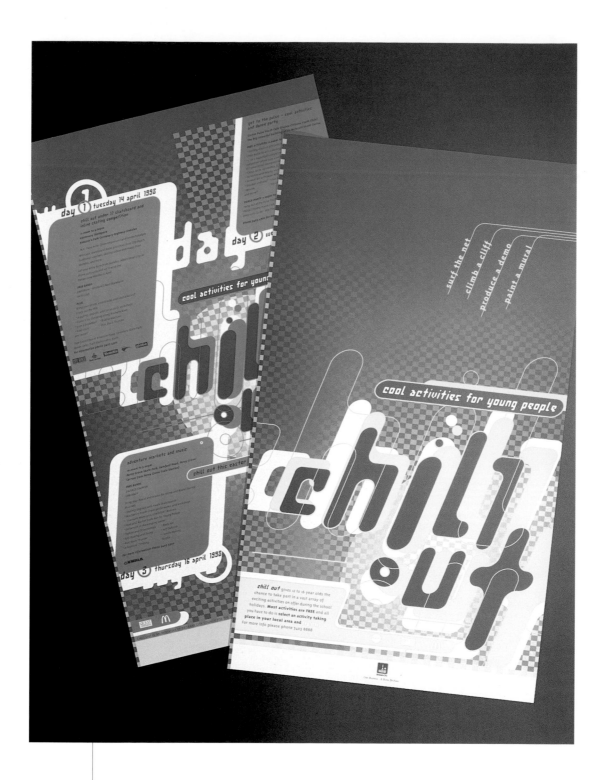

PROJECT> "Chill Out" Posters
DESIGN FIRM> Inkahoots Design,
Brisbane, Queensland, Australia
CLIENT> Brisbane City Council,
Brisbane, Queensland, Australia
ART DIRECTOR/DESIGNER> Jason Grant
ILLUSTRATOR> Steve Alexander

Bold type, colors, and textures, with a
logical flow of information in an
energetic layout, combine to make this
a strong design. The four-time repeat
of the "Chill Out" title text adds
sufficient emphasis to make it stand
out from the background.

PROJECT> American Institute
for Graphic Arts New Orleans Poster
DESIGN FIRM> Sagmeister, Inc.,
New York, New York, USA
CLIENT> American Institute
for Graphic Arts,
New York, New York, USA
ART DIRECTOR> Stefan Sagmeister
DESIGNERS> Hjalti Karlsson,
Stefan Sagmeister
ILLUSTRATORS> Peggy Chuang,
Katumi Matsumoto, Raphael Rudisser,
Stefan Sagmeister

Strength can be evoked through chaos, which the Sagmeister design team proves in this poster for an AIGA conference announcement that combines the talents of numerous illustrators and hypnotic copy.

chaleureux = warm = morno = caluroso = coudio = 運動感＝温かい

There was a great term in the 1980s for intimate, nonsexual, friendly gestures. They were known as *warm fuzzies*. Warm design attempts to convey those sentiments visually, to give viewers a touch of emotional warmth. Warm solutions range from the blatant to the ambient, from a grandmother with open arms, a student receiving a diploma, a puppy getting a pat on the head, or people hugging, to a warm fireplace, a pair of slippers, a family dinner scene, or a garden swing. The textures are slightly cliché, with blurred edges and softened images. The colors are similarly soft, though the range is rather broad.

"You need to explain who really needs to interact with the design. Clients usually confuse what they think is good with what their public thinks is good. But there are some exceptions. Good clients always promote good design!"

Rafael Peixoto Ferreira,
Rafa Ferreira Design

PROJECT> Gay Pride Day
1996 and 1997 Advertisements
DESIGN FIRM> Terrapin Graphics,
Toronto, Ontario, Canada
CLIENT> Ontario Federation of Labour,
Toronto, Ontario, Canada
ART DIRECTOR/DESIGNER> James Peters
ILLUSTRATOR> James Peters
PHOTOGRAPHER> Helen Daley

It can be challenging to bring warmth to black-and-white designs, especially those printed in newspapers, where the reproduction quality is less than optimal. The largest element in this ad for Gay Pride Day, 1997, in Ontario, Canada, is the pair of hands making gentle contact. The downcast, nearly closed eyes and the softened image of the face in profile create warm tones. This is an intimate view. The informal font echoes the central message of the advertisement, while the reversed type adds style and conserves space, allowing room for a larger image.

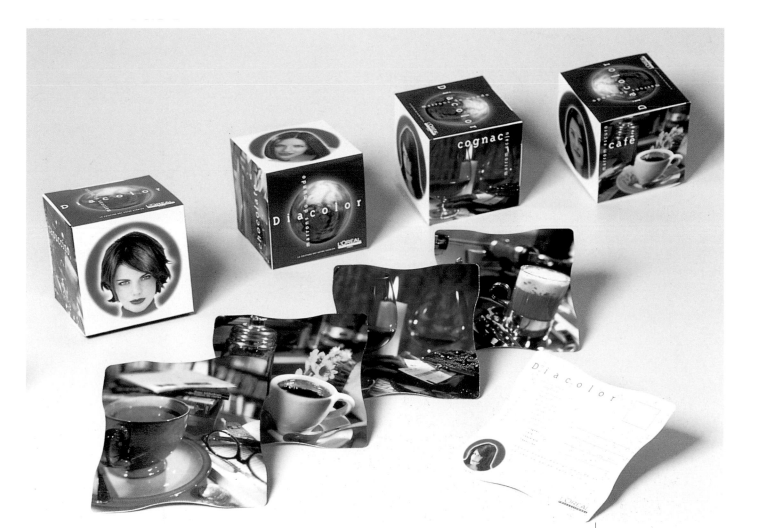

PROJECT> Diacolor Brochure,
Postcards, and Display
DESIGN FIRM> Ana Couto Design,
Rio de Janeiro, Brazil
CLIENT> L'Oreal, Rio de Janeiro, Brazil
ART DIRECTORS> Ana Couto, Natascha Brasil
DESIGNERS> Natascha Brasil,
Cristiana Nogueira
PHOTOGRAPHERS> Lisle Borges,
Ricardo Cunha (L'Oreal)

These promotional materials and packaging, created by Ana Couto Design for L'Oreal's Diacolors line, are a study in warmth. The coffees and cognacs, the candlelight, and even the gentle curves of the postcards give a direct softness and warmth.

PROJECT> **Resource Games**
Maptitude Packaging
DESIGN FIRM> **Hornall Anderson**
Design Works, Inc.,
Seattle, Washington, USA
CLIENT> **Resource Games,**
Redmond, Washington, USA
ART DIRECTOR> **Jack Anderson**
DESIGNERS> **Jack Anderson, Jana Nishi,**
Heidi Favour, David Bates, Sonja Max
ILLUSTRATOR> **Denise Weir**

While the visual message echoes Casey Kasem's famous signoff, "Keep your feet on the ground and keep reaching for the stars," the open-armed posture is also friendly and welcoming. Combined with red and orange as the predominant colors, the overall effect is at once warm, inviting, and inspiring to this educational game's youthful target audience.

PROJECT> **Empório Santa Luíza**
Corporate Identity
DESIGN FIRM> **BAC Propaganda/**
Rafa Ferreira Design,
Campinas, SP, Brazil
CLIENT> **Empório Santa Luíza,**
Campinas, SP, Brazil
ART DIRECTOR/DESIGNER> **Rafael Peixoto Ferreira**
PHOTOGRAPHER> **Corel Stock Photos**

It is commonly said that nothing is as warm as a mother's love. In Brazil, the Blessed Virgin is the embodiment of that love. As the visual identity for the Empório Santa Luíza, this mother, gazing lovingly down, offers that love to shoppers. While this might not work in countries where Catholicism is less a part of everyday life, it is a strong image for Brazilian viewers.

A design solution that appears young to its viewers emanates freshness and vigor from its type selection and treatment to its images and organization. Progress, development, and an absence of mature sophistication are other underlying messages that a youthful presentation can convey. Childhood images and styles are the anchored end of youthful design. From the clichés of reversed letters interspersed with hand-drawn headers to primary colors and crayon drawings, the graphics of childhood are a direct contrast to reflections of teen styles. These change from year to year with shifts in trends and styles.

"Clients, in general, are more worried about the economic aspect of the business; designers are more involved with the aesthetics. A good designer should try to combine both."

Regina Fernandes,
Redesign

jeune = jung = jong = jovem = joven = nuovo = 朝氣 = 少壮気鋭 = young

PROJECT> **National Sports Festival**
Character Design
DESIGN FIRM> **Mihama Creative Associates,**
Yokohama, Japan
CLIENT> **Kanagawa Prefectural Office,**
National Sports Festival,
Kanagawa, Japan
DESIGNER/ILLUSTRATOR> **Kimihiko Yoshimura**

Japan has long been renowned among animation fans for its anime. These characters from Mihama Creative Associates for a National Sports Festival design competition are exceptional. Japanese cartoon styles have infiltrated just about every country in the world, either through import or imitation. Though cartoons are normally associated with children, anime-style images have proven to have broad appeal with adults, too.

PROJECT> Perplexing Paintings
Museum Information Package
DESIGN FIRM> Hal Apple Design,
Manhattan Beach, California, USA
CLIENT> J. Paul Getty Museum,
Pacific Palisades, California, USA
ART DIRECTOR> Hal Apple

A transparent lunchbox is to a child what a brushed aluminum briefcase is to a businessman: easily identifiable and fun. In a collaborative effort with the J. Paul Getty Museum, Hal Apple Design created this series of children's educational games to enrich children's visits to the museum.

PROJECT> Maryland Institute
College of Art Search Poster
DESIGN FIRM> Grafik Communications,
Alexandria, Virginia, USA
CLIENT> Maryland Institute College of Art,
Baltimore, Maryland, USA
DESIGNERS> Jonathan Amen, Gregg
Glaviano, Judy Kirpich
PHOTOGRAPHER> Joe Rubino
ILLUSTRATOR> Jonathan Amen

The design team was charged with creating a keepsake that would intrigue high-school seniors and entice them to learn more about attending this art school. The team developed a deck of playing cards that visually described the school through 52 representations that conveyed a youthful image. The style of each card is different, appealing to a broad range of open-minded viewer tastes.

PROJECT> Kapitein Koek
Consumer Introduction
DESIGN FIRM> Designstudio Kees Uittenhout BMO,
Wijk en Aalburg, Netherlands
CLIENT> Peijnenburg Royal Bakeries,
Geldrop, Netherlands
ART DIRECTOR> Kees Uittenhout
DESIGNERS> Mik Wolkers,
Nico van Cromvoirt
PHOTOGRAPHER> Studio Hugo de Hey
ILLUSTRATORS> Mik Wolkers,
Nico van Cromvoirt

Designing for children can be the test of a studio's ability to create lively packaging. In this display joint promotion, Designstudio Kees Uittenhout brings the brand's mascot, Kapitein Koek, to vibrant life throughout the series of images.

PROJECT> **Mohawk Paper Mills Tomahawk Promotional Booklet**
DESIGN FIRM> **Hornall Anderson Design Works, Inc., Seattle, Washington, USA**
CLIENT> **Mohawk Paper Mills, Cohoes, New York, USA**
ART DIRECTORS> **Jack Anderson, Lisa Cerveny**
DESIGNERS> **Jack Anderson, Lisa Cerveny, Mary Hermes, Jana Nishi, Jana Wilson Esser, Virginia Le**
PHOTOGRAPHER> **Tom Collicott**
ILLUSTRATOR> **Dave Julian**

Young design does not have to target children. The artistic caprice of this Mohawk Paper promotional booklet might be captivating to a child, but it will also hold adults' attention and is an outstanding demonstration of the capabilities of Mohawk's products and of the Hornall Anderson design team's imagination.

THE ONTARIO FEDERATION OF LABOUR

OFL/FTO

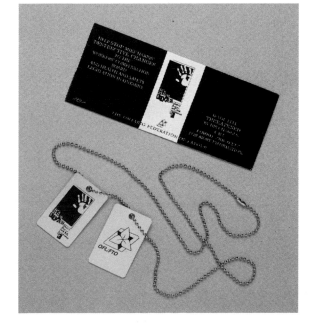

PROJECT> **Ontario Federation of Labour It's Your Life Brochure**

DESIGN FIRM> **Terrapin Graphics, Toronto, Ontario, Canada**

CLIENT> **Ontario Federation of Labour, Toronto, Ontario, Canada**

ART DIRECTOR/DESIGNER> **James Peters**

PHOTOGRAPHER> **Helen Daley**

ILLUSTRATOR> **James Peters**

Faux dogtags have joined the fashion accessories of a large segment of older urban youth. In nightclubs and skate parks, they are a fairly common sight. These youths are also entering the workforce. Thus, this work-safety campaign effectively reaches the people most at risk. The strength of the artistry of the campaign also assures that it will not be ignored.

contributors

Amoeba Corporation
49 Spadina Avenue, Suite 507
Toronto, ONT M5V 2J1 CANADA
TEL: 416/599-2699
FAX: 416/599-2391
info@amoebacorp.com

Ana Couto Design
Rua Joana Angélica, 173- 3º andar
Rio de Janeiro 22420-030 BRAZIL
TEL: +55-21/287-7069
FAX: +55-21/287-7069
amelegari@anacouto-design.com.br

**Barbara Harkness Graphic
Design Pty., Ltd.**
Suite 3, 2 East Terrace
Adelaide, SA 5000 AUSTRALIA
TEL: +08/8223-1855
FAX: +08/8223-2600
bhdesign@dove.net.au

Bigital
José León Pagano 2646 7mo. B
Buenos Aires, RA 1425 ARGENTINA
TEL: +54-1/802-9680
FAX: +54-1/802-9680
info@bigital.com

Bo2 Productions
101-250 West Esplanade Street
North Vancouver, BC V7M 3G7 CANADA
TEL: 604/987-0909
FAX: 604/904-4433
pezhman@bo2.com

The Bonsey Design Partnership
179 River Valley Road, Level 5, Unit 1
Singapore 179033 SINGAPORE
TEL: +65/339-0428
FAX: +65/339-0418
postmaster@bonsey.com.sg

Clic Limited
Ste. 801, Kornhill Metro Tower, 1 Kornhill Road
Quarry Bay, HKSAR CHINA
TEL: 852/2513-8386
FAX: 852/2513-8390
clic@clic.com.hk

Designstudio Kees Uittenhout BMO
Galerij 15
Wijk en Aalburg, Brabant
U261DG NETHERLANDS
TEL: +31-416/69-2507
FAX: +31-416/69-2557
uittenhout@uittenhout.nl

**Dirk Rullkötter AGD
(Advertising + Design)**
Kleines Heenfeld 19
Kirchlengern 32278 GERMANY
TEL: +49-5223/7.34.90
FAX: +49-5223/76-02-30
info@rullkoetter.iok.net

e-media-c
1199 North Fairfax Street, Suite 700
Alexandria, VA 22314 USA
TEL: 703/683-0511
FAX: 703/683-3740
eric@e-media-c.com

Grafik Communications
1199 North Fairfax Street, Suite 700
Alexandria, VA 22314 USA
TEL: 703/683-4686
FAX: 703/683-3740
liz@grafik.com

Hal Apple Design
1112 Ocean Drive, Suite 203
Manhattan Beach, CA 90266 USA
TEL: 310/318-3823
FAX: 310/318-1914
halapple@halappledesign.com

Haymarket Publications
22 Chalford Avenue
Swindon, Wiltshire SN3 3NS ENGLAND
TEL: +44/1793-524255
100657.1534@compuserve.com

Hornall Anderson Design Works, Inc.
1008 Western Boulevard, Sixth Floor
Seattle, WA 98104 USA
TEL: 206/467-5800
FAX: 206/467-6411
carbini@hadw.com

Inkahoots Design
239 Boundary Street, West End
Brisbane, Queensland 4101 AUSTRALIA
TEL: +61-7/3255-0800
FAX: +61-7/3255-0801
inkahoot@thehub.com.au

Intro
35 Little Russell Street
London WC1A 2HH ENGLAND
TEL: +44-171/637-1231
FAX: +44-171/636-5015
adrian@introdesign.com

Lieber Brewster Design, Inc.
19 West 34 Street, Suite 618
New York, NY 10001 USA
TEL: 212/279-9029
FAX: 212/279-9063
lieber@interport.net

Lland Graphics
29 Colston Manor
Glasgow, Strathclyde G64 1SL SCOTLAND
TEL: +44-141/772-6745
FAX: +44-141/771-6745
graphics@lland.demon.co.uk

Macnab Design Visual Communication
400 San Felipe NW, Suite 4
Albuquerque, NM 87104 USA
TEL: 505/242-6159
FAX: 505/242-7710
mmacnab@macnabdesign.com

**Miguel Jorge Solak/
Corh Consultores**
Lavapiés, 29 - 2º 6
Madrid 28012 SPAIN
TEL: +34-91/5397721
FAX: +34-91/3515628
corh@stnet.es

Mihama Creative Associates
7-19-19 Sasage Konan-ku
Yokohama 234-0052 JAPAN
TEL: +81-45/846-3128
FAX: +81-45/846-3128
kentmca@cap.bekkoame.ne.jp

Mires Design, Inc.
2345 Kettner Boulevard
San Diego, CA 92101 USA
TEL: 619/234-6631
FAX: 619/234-1807

Neo-Graphic Communications
3520 Wiltshire Drive
Nanaimo, BC V9T 5K1 CANADA
TEL: 250/758-6505
FAX: 250/758-8751
design@neo-graphic.com

Orbit Integrated
722 Yorklyn Road, Suite 150
Hockessin, DE 19707 USA
TEL: 302/234-5700
FAX: 302/234-5700
mark.hahn@theorbit.com

The Partners
Albion Courtyard, Greenhill Rents,
Smithfield, London EC1M 6BN ENGLAND
TEL: +44-171/608-0051
FAX: +44-171/250-3917
mktg@partnersdesign.co.uk

Rafa Ferreira Design/
BAC Propaganda
Orozimbo Maia 2090-ap 17
Campinas, SP 13024-030 BRAZIL
TEL: +55-019/255-4985
FAX: +55-019/255-4985
rfdesign@dglnet.com.br

Redesign
14 (3F) High Street, Tweeddale Court
Edinburgh EH1 1TE SCOTLAND
TEL: +44-131/557-9243
FAX: +44-131/557-3632
regina@aisl.co.uk

Sagmeister, Inc.
222 West 14 Street, Suite 15A
New York, NY 10011 USA
TEL: 212/647-1789
FAX: 212/647-1788

M. Shanken Communications, Inc.
387 Park Avenue South
New York, NY 10016 USA
TEL: 212/684-4224
FAX: 212/481-0724
ediamant@mshanken.com

Studio Moo
389 Manchester Road, Heaton Moor
Stockport, Cheshire SK4 5BY ENGLAND
TEL: +44-161/432-1372
Bri@moo.source.co.uk

Terrapin Graphics
991 Avenue Road
Toronto, Ontario M5P 2K9 CANADA
TEL: 416/932-8832
FAX: 416/487-8670
james@terrapin-graphics.com

University of Delaware
Department of Art
104 Recitation Hall
Newark, DE 19716 USA
TEL: 302/831-2244
FAX. 302/831-0505
martha.carothers@mvs.udel.edu

U.R.L. Agentur für
Informationsdesign GmbH
Seidengasse 26
Vienna A-1120 Wien AUSTRIA
TEL: +43-1/523.53.43
FAX: +43-1/523.53.43-33
office@url.co.at

Volksmedia
608 Gonzalez Drive
San Francisco, CA 94132 USA
TEL: 415/333-8300
FAX: 415/337-9417
info@volksmedia.net

Yfactor, Inc.
16 Pretty Place
Brampton, ONT L6S 5C6 CANADA
TEL: 905/793-5016
FAX: 905/792-2065
info@yfactor.com

LIBRARY & RESOURCES AREA - EPSOM CAMPUS

THE SURREY INSTITUTE OF ART & DESIGN

index

abouttheauthors

Authors Anistatia R Miller and Jared M. Brown wrote
and designed *Shaken Not Stirred*®: *A Celebration of
the Martini,* which was published in both English
(HarperCollins Publishers) and German (EuropaVerlag).
They recently produced a sequel, *Champagne Cocktails*
(Regan Books). They also wrote both *What Logos Do
and How They Do It* and *Design Sense*, published by
Rockport Publishers in 1998. They are former con-
tributing editors to *Adobe* magazine's on-line edition,
adobemag.com, and wrote feature articles for its
print edition, *Adobe* magazine. They have also
recently written for *Wine Spectator, Cigar Aficionado*,
and *Icon: Thoughtstyle* magazine.

Their first Web site—*Shaken Not Stirred*®: *A
Celebration of the Martini*—went up on Halloween
night, 1995, and earned them four stars from *Web
Review* in November 1995, three stars from Magellan
(the *McKinley Review*), a **Top 5%** of the Internet rating
by Point Survey, and a **GIST Web Pick** in May 1997, in
addition to numerous other awards. The site also
became an **Excite-seeing Tourstop** and was featured
on America On-Line's **Vices & Virtues** channel. They
have also designed Web sites for the Franklin Delano
Roosevelt Memorial Commission in Washington, DC,
Potomac Engineering in Chicago, and for Illinois
College of Optometry.